POSTCARD HISTORY SERIES

Harrodsburg and Mercer County

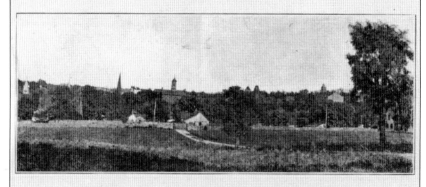

The Little Town in Mercer

'Way down in Old Kentucky,
"Where the meadow-grass is
blue"—
Where they count the time by
heart-throbs,
Beating faithfully and true—
Where the summer breeze
makes music
'Mid the corn that tassels high,
Where the colors of the stream-
lets
Blend the colors of the sky,

Stands that little town in Mercer
Closely nestled 'mid the
green—
Stands that cradle of Kentucky,
On the fairest spot e'er seen;
There I hear the robins twitter
From their nest up in the
tree,
And the whistle of the red bird,
All in love, is calling me.

There the voice of men and
women,

Sounding ever in my ears,
With a sweeter, sweeter music
Than the music of the spheres,
May I ne'er, no ne'er forget
thee,
When my head is turning gray,
May the light which shines above
thee,
Shine upon my latest day.

May the greenness of thy mea-
dows
Be the greenness of that sod
Which shall cover up my body
When its soul has gone to God.
As the Swiss heart to the moun-
tain,
As the sailor's to the sea,
So my heart it is to Mercer
Where-so-ever I may be,

Tho' the ocean roll between us—
Tho' far, far away I roam—
Oh, my heart it is in Mercer,
For 'tis home, my sweet,
sweet home.

F. S. R.

A Mercer County native thought this area was "God's country" and wrote about it in a poem in 1924. The photograph was taken from a high point near Fort Harrod, looking east toward Harrodsburg. The sharp steeple on the left is St. Philip's Episcopal Church, to its right is the courthouse clock tower, next is the Harrodsburg Christian Church, and to the far right is United Presbyterian Church's steeple.

ON THE FRONT COVER: On the front cover are "bathing beauties of the 1950s" posing at Chimney Rock Resort on Herrington Lake. The young women are, from left to right, (standing and sitting on the rail) Mary Chambliss Waters, Elinor Patterson, Betty Ann Stoll Haley, Barbara Jean Humber, Sitty Russell, and Ann Park; (sitting on the pool deck) Genie Carpenter Bissett, unidentified, Frances Barnett, and Mary Louise Patterson.

ON THE BACK COVER: This is a 1940s view of Harrodsburg's Main Street in its heyday.

POSTCARD HISTORY SERIES

Harrodsburg and Mercer County

Anna Armstrong

ARCADIA
PUBLISHING

Published by Arcadia Publishing
Charleston, South Carolina

Printed in the United States of America

Library of Congress Control Number: 2012947367

For all general information contact Arcadia Publishing at:
Telephone 843-853-2070
Fax 843-853-0044
E-mail sales@arcadiapublishing.com
For customer service and orders:
Toll-Free 1-888-313-2665

Visit us on the Internet at www.arcadiapublishing.com

This book is dedicated to all who have ever gone through a loved one's possessions and not thrown away these interesting bits of history—postcards— but instead preserved them for others to enjoy. Thank you.

CONTENTS

FOREWORD

Anna Armstrong is inspirational as, once again, she recognizes and articulates the importance of preserving memory of place. She savors her work, and she knows Harrodsburg and Mercer County well. Her reverence for the community where she has spent her life, as well as her devotion to preservation, is evident. It is obvious that for her, self-discipline is an essential component to accomplishment. Her discipline turns into productivity and creates a collection that is a gift to this community.

In Arcadia Publishing's Postcard History Series: *Harrodsburg and Mercer County*, she not only celebrates the photographers who created picture postcards of our community but also gives us a social history of architecture and life in Harrodsburg and Mercer County. There is great value in looking back into the past through this lens. As in her previous book, she continues to faithfully record the sense of this place. Her postcards are well collected, annotated, informative, and entertaining, helping the viewers conjure up postcard memories of their own. To borrow a quote from C.S. Lewis, postcards "baptize one's imagination."

Let looking at postcards help us salute the built environment, culture, heritage, and sense of community that have made this place what it is.

—Lois Mateus
July 2012

ACKNOWLEDGMENTS

First and foremost, I want to acknowledge the legacy of history, art, and photography that my late father, Andrew Armstrong, and his late sister Jesta Bell Armstrong Matherly left.

In addition, I want to thank the following people for their assistance, whether with information or a gift of some "old postcards I found in the drawer." They are Jim Miller, Michael Wiser, Sara Frances Woods, Emeline Woods, Louise Dean, and the late Jack Bailey. Organizations to which I am indebted for help are the Mercer County Public Library, the Harrodsburg Historical Society, and the University of Kentucky Archives and Special Collections department. And a special thank-you goes to Lois Mateus for writing the foreword.

All material in this book is from the Armstrong Archives unless otherwise noted.

INTRODUCTION

Postcards have always interested me, both for the subject matter on the front and the message on the back. For someone interested in history, they offer a quick show-and-tell of a particular time or place. This collection of Harrodsburg and Mercer County postcards was a natural offshoot of my interest in photography. Between the two mediums, there emerged a much more thorough and complete coverage of the subject matter—one complements the other.

The hobby of collecting postcards used to be an adventure, which involved a day trip to a postcard show or a trip to a town not too far away to search out antique stores that might have a postcard booth. Flea malls often offered the greatest variety of cards for the best price. A good place to eat and some interesting shopping opportunities were also important. But eBay has changed all that, at least for me. It is still good to get out from time to time, but there is no comparison between what you can find on the Internet and what you might come home with after a day's shopping. The world is at your fingertips, and the possibilities are endless.

Postcards have been around since the turn of the century, and the term "postcard" was first printed on cards in 1901. Postcard images of prominent buildings or scenes in towns both large and small became available in the early 1900s. Some of Harrodsburg's earliest cards were of the courthouse, Main Street scenes, Colonial homes, and Fort Harrod. Harrodsburg was fortunate to have two photographers, A.B. Rue and H.C. Wood, whose photographs were used on numerous local postcards. But postcards are not an all-inclusive picture of a town. It is interesting what appears to have been left out, and you wonder just how the photographer chose between one thing or another. Harrodsburg, for instance, is lacking in cards of the west side of Main Street, whereas the east side is well documented. Was it just a matter of the time of day they happened to be there and the position of the sun? Regardless, we are thankful for whatever we have.

Harrodsburg's major attractions were well documented during the early years, but it is interesting that there have been next to no postcards produced in modern times. But of course, the changing way we communicate now is responsible for that. You have to look long and hard to find any "new" postcards when traveling.

This book was put together mainly from my personal collection of cards, which I have either bought or received from people who are cleaning out after the death of a loved one. Often, a boxful of "stuff," with items like photographs, postcards, and newspapers, is given to me by people who do not know what to do with it because they think it might have some value or do not feel good about throwing it away. Thank you, thank you, thank you for realizing that there is value in all these little pieces of history.

One

FORT HARROD

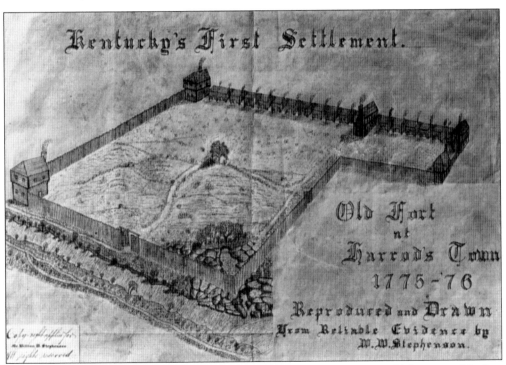

The research and writings of the Honorable W.W. Stephenson (1857–1914) were critical to the accurate reconstruction of Fort Harrod. Stephenson, a lifelong resident of Harrodsburg, prominent attorney, and legislator, insured the local historical heritage with his meticulous and extensive studies. This is a drawing by Stephenson from "reliable evidence" of what the original fort looked like. The el shown in this rendering was later removed, and the fort as it is known today is a rectangle.

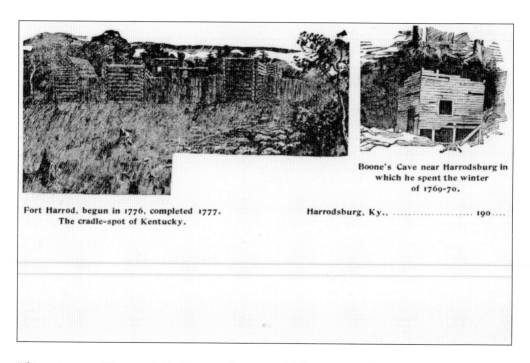

Boone's Cave near Harrodsburg in
which he spent the winter
of 1769-70.

Fort Harrod, begun in 1776, completed 1777.
The cradle-spot of Kentucky.

Harrodsburg, Ky., 190....

This private mailing card displays two images, which appear to be drawings—one of Fort Harrod and the other of Boone's cave. Private mailing cards were the second of seven types of postcards available to the public. This style of card only lasted for four years (1898–1901) and was the result of private printers being granted permission by Congress to print and sell them. Writing was not permitted on the address side, so any message had to be written on the front and would have been necessarily brief because of the images. Fort Harrod's start date of 1776 is incorrect on this postcard. By all accounts, James Harrod and his men came to the area in 1774, and the fort was established in 1775.

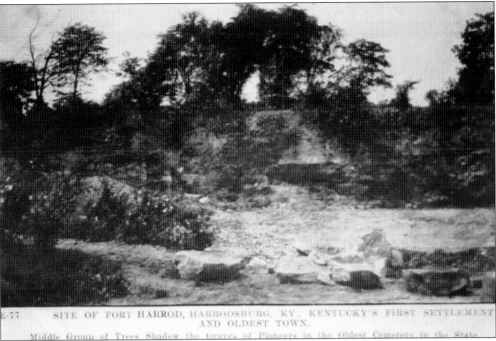

E-77 SITE OF FORT HARROD, HARRODSBURG, KY., KENTUCKY'S FIRST SETTLEMENT
AND OLDEST TOWN.

Middle Group of Trees Shadow the Graves of Pioneers in the Oldest Cemetery in the State.

Both postcards show what was known as Old Fort Hill, the site of the original Fort Harrod in 1775. A census taken in 1777 shows the fort population to be 198. By the mid-1800s, Indian raids had lessened, pioneers had moved out of the fort to claim land and build houses, and it was in disrepair. A rock quarry close to town was needed to supply stone for a growing community, and this rocky hill seemed like a good place. In the 1890s, a quarry was blasted out and provided the much-needed stone. A message on the card below to the sender's mother reads, "Fort Hill, Harrodsburg-Although equally sacred with Independence Hall-the vandal has left it in ruins." The quarry was eventually filled in and paved over for a parking lot for the reconstructed fort, which was located just to its south.

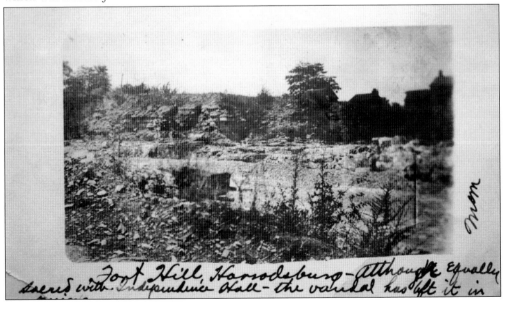

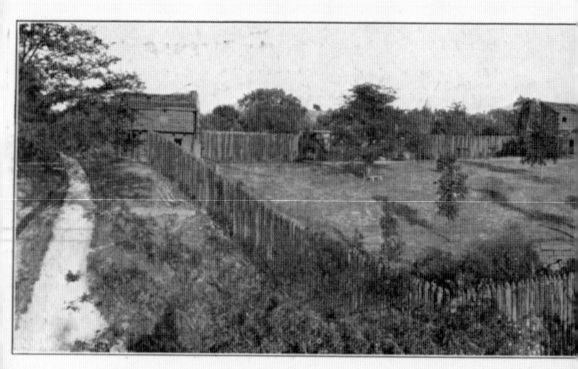

This 1920s panoramic view of Fort Harrod was published by Daniel M. Hutton, owner of the local newspaper *Harrodsburg Herald*, and was made from a photograph and hand colored. A one-cent stamp would cover the postage. A poem on the back of the card by Henry Cleveland Wood, Harrodsburg's poet laureate, is dedicated to Fort Harrod and reads, "O gray and silent

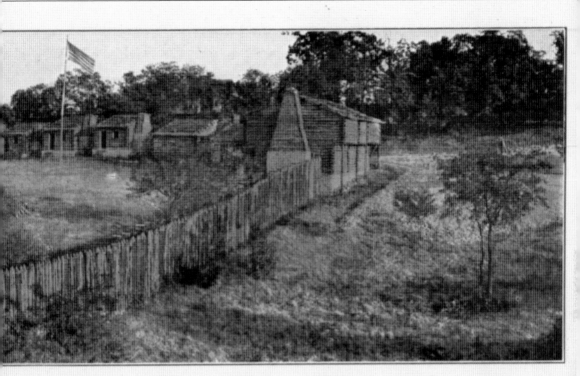

ARROD

sentinel! Upon Fort Harrod Hill-Could we glimpse your historic past, How great would be the thrill. For many stirring memories crowd thick upon the years, And haunt Kentucky's cradle spot-Home of our Pioneers." Also included on the back is a short history of the fort.

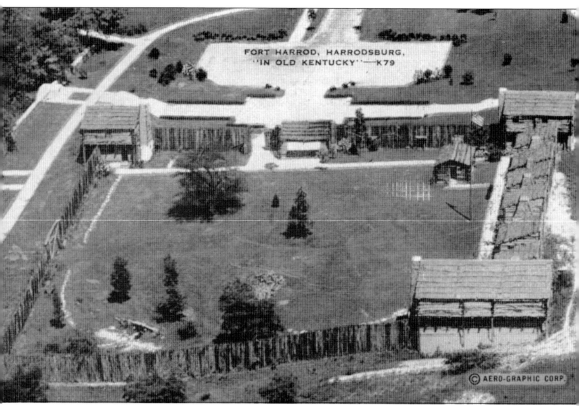

FORT HARROD, HARRODSBURG,
"IN OLD KENTUCKY" — K79

© AERO-GRAPHIC CORP.

This card shows an aerial view of Fort Harrod, which is located within Pioneer Memorial State Park. The site of the fort reproduction is just south of the original location on Old Fort Hill. The 23-acre park was the result of years of effort by members of the Pioneer Memorial Association, organized by local citizens in 1923. Their goal was a tribute to the first permanent white settlement west of the Allegheny Mountains. The association selected the site of the present park and raised support for the construction of a replica of James Harrod's fort. Responsive Kentuckians in every state donated money, which was used to purchase the land, which was then deeded to the Commonwealth of Kentucky. The Olmsted Brothers, landscape architects, were employed to lay out the park, and the fort reproduction was fully equipped as a museum. An addition to the original plans was the building of the Lincoln Marriage Temple, in which the cabin where Lincoln's parents were married was relocated. Also within the park is the Pioneer Cemetery, which was the first burying ground in the wilderness.

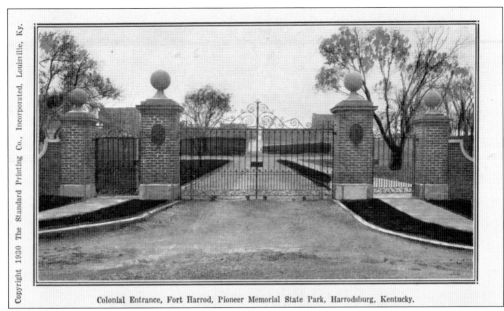

Colonial Entrance, Fort Harrod, Pioneer Memorial State Park, Harrodsburg, Kentucky.

The beautiful hand-wrought iron gates forming the entrance to Fort Harrod State Park were a gift from the Society of Colonial Dames of America and the Society of Sons of Colonial Wars in the Commonwealth of Kentucky. These two societies recognized Harrodsburg, founded in 1774, as Kentucky's only colonial town and as being two years older than the Declaration of Independence.

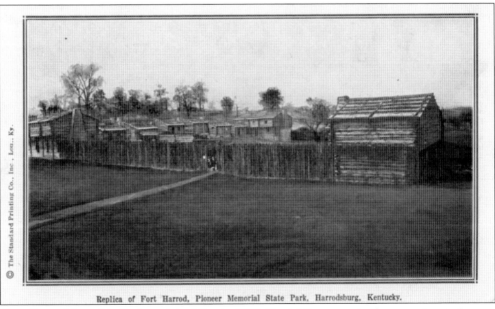

Replica of Fort Harrod, Pioneer Memorial State Park, Harrodsburg, Kentucky.

Capt. James Harrod built the original fort in 1775. Daniel Boone and other prominent pioneers assisted him. It was the extreme-western military post during the Revolutionary War. Here, the first preacher in Kentucky, the Rev. John Lythe, established the first "Temple of God" in the wilderness. Here, the first courts were held, and the practice of law was known in the forests of Kentucky for the first time.

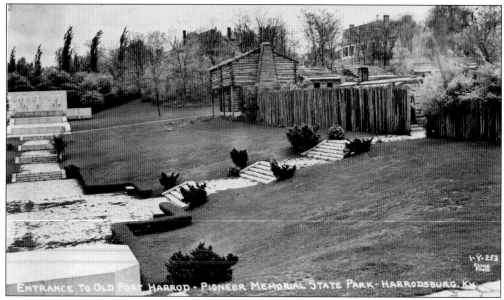

Although the origins of photography date to the 1820s, it was not until the turn of the century, after Eastman Kodak introduced a camera and postcard-size paper to print a negative on in 1902, that real-photo postcards became popular. This made personalized cards both affordable and convenient for everyone. The popularity of these cards lasted until shortly before World War II; although their golden era ended in the 1920s. A professional photographer named Cline, who traveled around Kentucky shooting its scenic attractions, took these photographs during the late 1940s or early 1950s. His cards were always in black and white and were extremely sharp and well composed, with identification of the scene hand-printed in white ink at the bottom. These cards show the park surrounding Fort Harrod has been attractively landscaped with stonework and plantings.

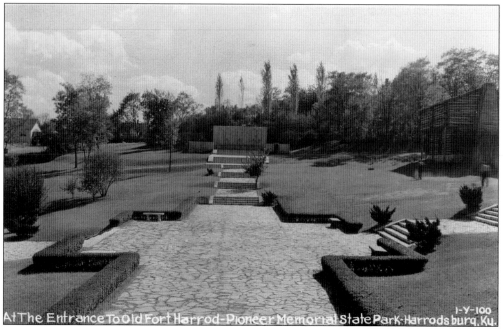

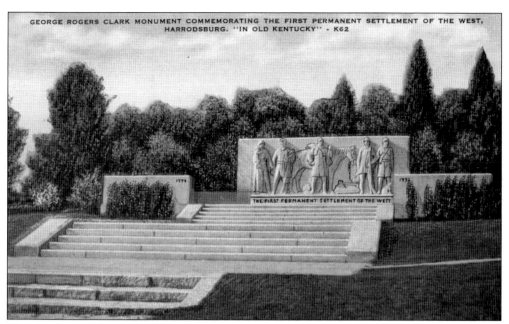

GEORGE ROGERS CLARK MONUMENT COMMEMORATING THE FIRST PERMANENT SETTLEMENT OF THE WEST, HARRODSBURG. "IN OLD KENTUCKY" - K62

The above view shows the George Rogers Clark Monument, which was dedicated before a crowd of some 60,000 on November 16, 1934, by Pres. Franklin D. Roosevelt. Below is a view showing the stone inlay, which traces the pioneer routes into the Northwest Territory. This card was posted March 2, 1938, to James Isenberg, St. Joseph Hospital, Lexington, Kentucky, from H.C. Wood, Harrodsburg's poet laureate. Isenberg was a driving force in the development of Fort Harrod State Park and the owner of the popular Blue Front department store. The card reads, "We are glad to hear that you are getting on fine and hope to see you soon. Your poem was beautiful. I shall have to look to my laurels." Isenberg died just eight months later in October 1938.

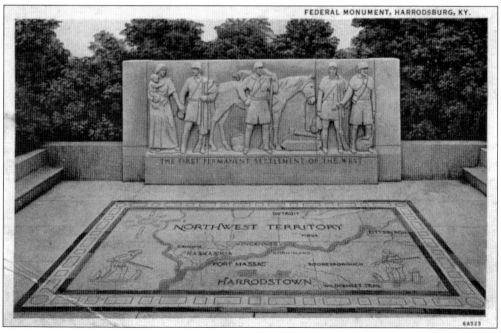

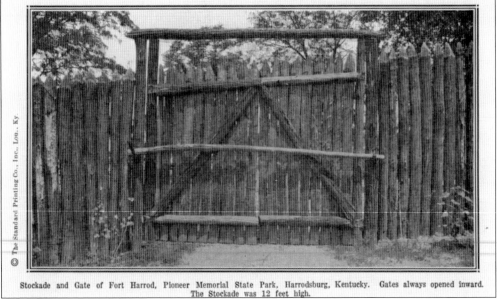

Stockade and Gate of Fort Harrod, Pioneer Memorial State Park, Harrodsburg, Kentucky. Gates always opened inward. The Stockade was 12 feet high.

This card shows a portion of the stockade and gate at Fort Harrod. Gates were 10 to 12 feet wide and always opened inward, as that was easier to handle in emergencies. The stoutest timbers were used with a heavy bar to secure it against attacks by Indians. Individual logs were called pickets and were usually cut from straight oak trees found nearby that were at least a foot in diameter.

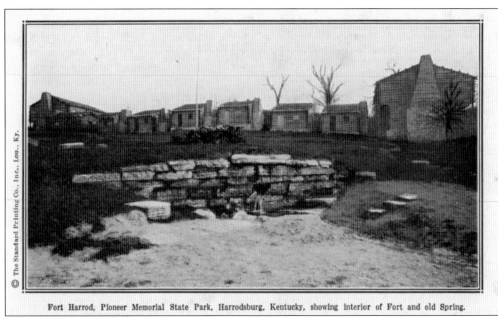

Fort Harrod, Pioneer Memorial State Park, Harrodsburg, Kentucky, showing interior of Fort and old Spring.

A spring was located inside Fort Harrod, which gave the settlers a safe supply of water during a siege. A trip for water to a spring located too far from the fort often ended in tragedy if the Indians attacked. Some water still trickles from this spring, but many have dried up due to disturbances of the underground streams by construction.

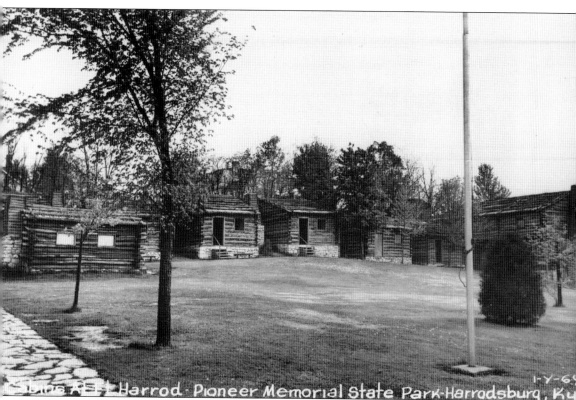

Cabins at Ft. Harrod - Pioneer Memorial State Park - Harrodsburg, Ky.

This interior view of the fort shows the row of cabins along the south wall. The following description is from a diary written by Benjamin Van Cleve in 1791 and reprinted in the *Harrodsburg Herald* in 1932: "The cabins are 20x20 story-and-a-half buildings with a roof sloping downward to the inside. There is a distance of 10 feet between cabins. They are chinked and pointed with clay mixed with straw as a binder. The doors and window shutters are of oak puncheons (heavy timbers finished on one side only) and secured by stout bars inside with a leather latchstring. A ladder of five rounds occupies the corner to access each cabin's attic, which always has a cask of water to be used in case of fire. The floors are usually earthen and have become packed hard and firm through constant use. There is a small fireplace in each cabin with an outside chimney made of sticks and clay. Most households possess one or more beds, a looking glass and a few chairs."

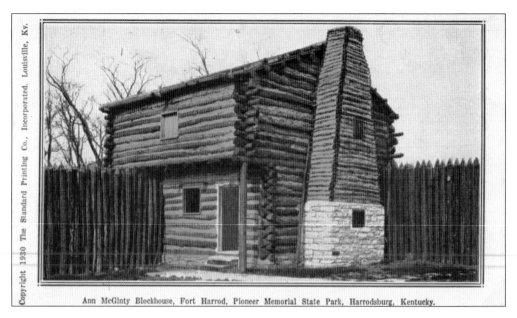

Ann McGinty Blockhouse, Fort Harrod, Pioneer Memorial State Park, Harrodsburg, Kentucky.

Blockhouses were built primarily to provide defense for the fort. Because of their size, they also provided common space for activities such as spinning, weaving, and churning. The Ann McGinty Blockhouse is one of three located in the corners of the fort. These two-story buildings measure about 25 by 45 feet, with the upper story extending two feet out from the walls. This overhang made it hard for Indians to scale and also gave the pioneers a high vantage point for shooting. McGinty is known as the first home economics demonstrator in Kentucky. She brought her spinning wheel on her horse as she traveled the Wilderness Road to Fort Harrod. She survived four husbands, lived into old age, and died in the blockhouse bearing her name. The relics displayed in this building are a museum of the implements used by pioneer women to supply their household needs.

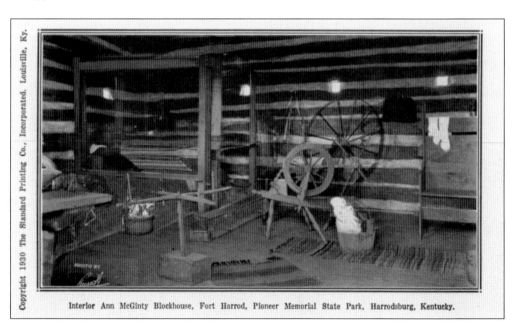

Interior Ann McGinty Blockhouse, Fort Harrod, Pioneer Memorial State Park, Harrodsburg, Kentucky.

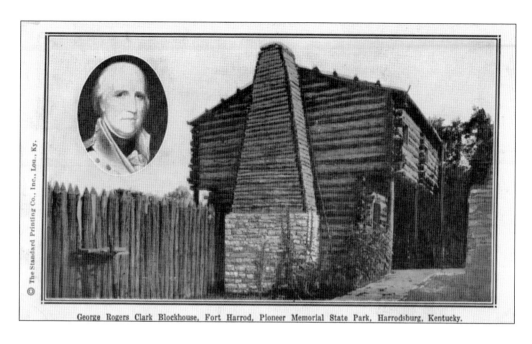

George Rogers Clark Blockhouse, Fort Harrod, Pioneer Memorial State Park, Harrodsburg, Kentucky.

These two cards show the exterior and interior of the blockhouse named for Gen. George Rogers Clark, pioneer statesman and military leader. Clark came to Fort Harrod in 1775 at the age of 23. There, he studied the big problems confronting the settlers on the western frontier during the Revolutionary War, conceived the idea of clearing that frontier of enemies, and in 1778, left Fort Harrod to begin his conquest of the Northwest Territory. The blockhouse contains the flintlock guns of the pioneers, their bullet molds, powder horns, and swords used during the Revolutionary War in the West. Weapons used by the Indians before the British supplied them with arms and ammunition to use against the Americans can also be seen there.

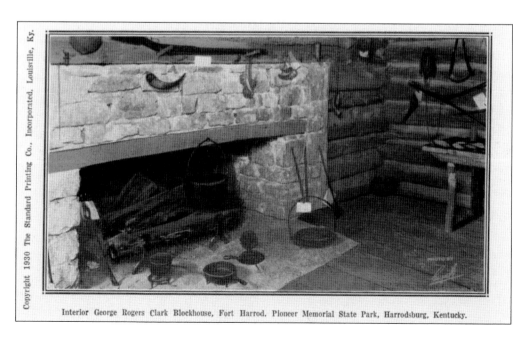

Interior George Rogers Clark Blockhouse, Fort Harrod, Pioneer Memorial State Park, Harrodsburg, Kentucky.

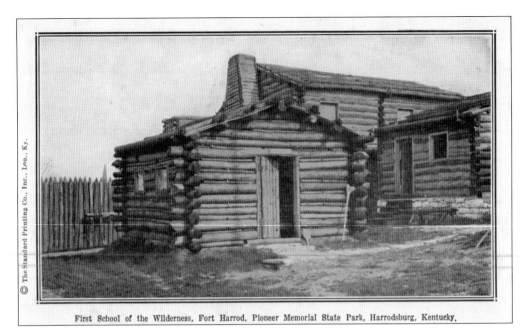

First School of the Wilderness, Fort Harrod, Pioneer Memorial State Park, Harrodsburg, Kentucky.

In 1776, in this cabin in Fort Harrod, Jane Coomes taught the first "school of the wilderness while Indians prowled outside the stockade walls." The school was a one-room log structure with an earthen floor, windows of heavy paper greased with bear fat, and no chinking in the walls. This open space between the logs helped to let in air and light. There was an unusually large fireplace opposite the front door, which opened to the outside and allowed long logs to be fed into the fire. The children sat on split log benches while they learned their ABCs from wooden paddles, which imitated Old English hornbooks of the 1600s. Some also learned to read from the Bible. Coomes taught in Fort Harrod for nine years.

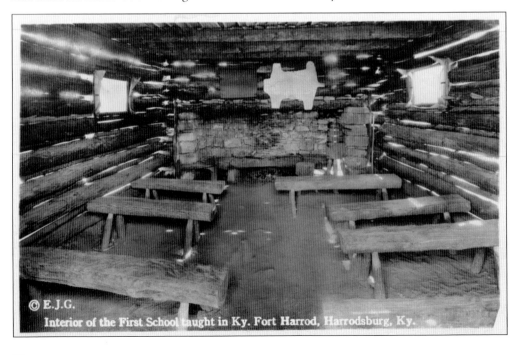

© E.J.G.
Interior of the First School taught in Ky. Fort Harrod, Harrodsburg, Ky.

22

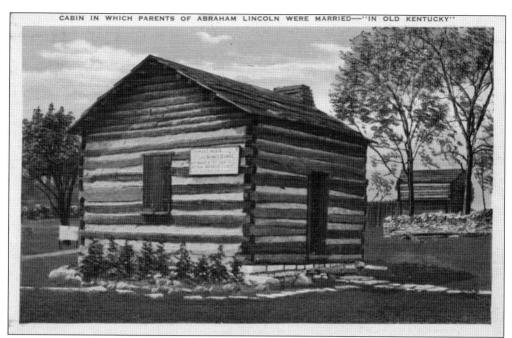

In this cabin on June 12, 1806, Thomas Lincoln and Nancy Hanks, the parents of Abraham Lincoln, were married by the Rev. Jesse Head, an ordained minister and resident of Harrodsburg. The cabin was presented to the Harrodsburg Historical Society in 1911 and moved from its original location in Washington County, Kentucky, to Fort Harrod. It was later deeded to the Commonwealth of Kentucky. The card below shows the Lincoln Marriage Temple, which was built as a shelter for the cabin and was dedicated on June 12, 1931. The building was a gift of Isabel Ball of Muncie, Indiana, in memory of her parents. Abraham Lincoln's life had been an inspiration to the entire Ball family, and they wished to bring attention to and verify the marriage of his parents, who had been the subject of rumors saying they were unmarried.

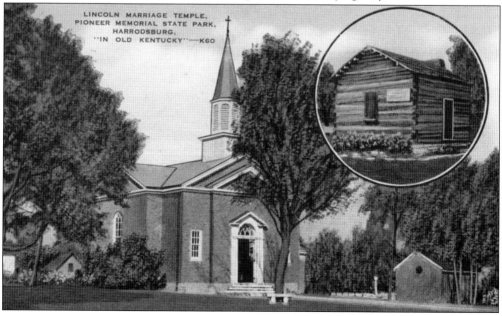

LINCOLN MARRIAGE TEMPLE,
PIONEER MEMORIAL STATE PARK,
HARRODSBURG,
"IN OLD KENTUCKY"—K60

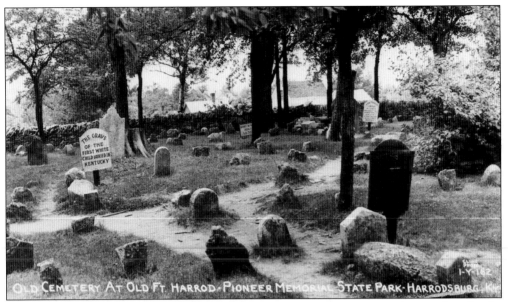

OLD CEMETERY AT OLD FT. HARROD-PIONEER MEMORIAL STATE PARK-HARRODSBURG, KY.

This real-photo postcard showing the Pioneer Cemetery at Fort Harrod was taken in the 1940s. This "First God's Acre of the Wilderness" is believed to hold close to 500 pioneers, although time has reduced the number of identifiable graves to a handful. The cemetery is unique in that there are eight distinct periods of grave markings—from those of the settlers who used fieldstones set edgewise with no marking on them to the Italian marble used later in the century. Early cemetery census reports place the last burials here in the 1840s. According to well-authenticated tradition, this cemetery holds the remains of the first white child buried in Kentucky, which is marked by a small coffin-shaped sarcophagus and an unmarked head stone. The card below shows the stone of Ann McGinty, who died in 1815.

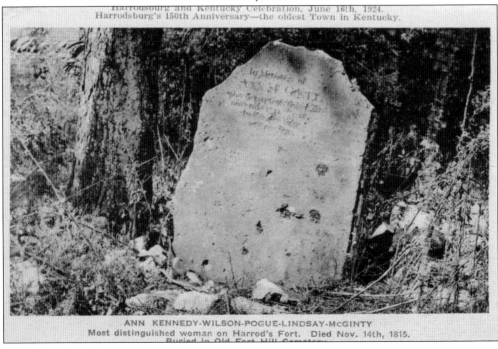

Harrodsburg and Kentucky Celebration, June 16th, 1924.
Harrodsburg's 150th Anniversary—the oldest Town in Kentucky.

ANN KENNEDY-WILSON-POGUE-LINDSAY-McGINTY
Most distinguished woman on Harrod's Fort. Died Nov. 14th, 1815.
Buried in Old Fort Hill Cemetery.

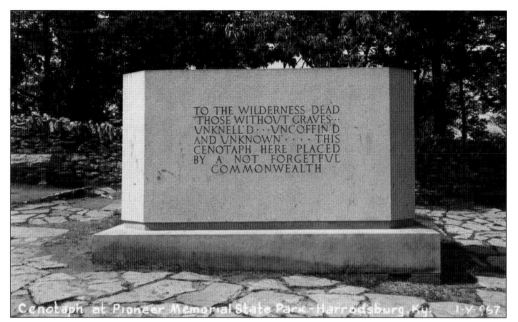

Standing just outside Pioneer Cemetery is a monument known as a cenotaph, which is a memorial erected in honor of those whose bodies lie elsewhere. When it was unveiled on November 16, 1934, during Pres. Franklin Roosevelt's trip here to dedicate the memorial to George Rogers Clark, Kentucky was the first state in the Union to honor its unknown dead.

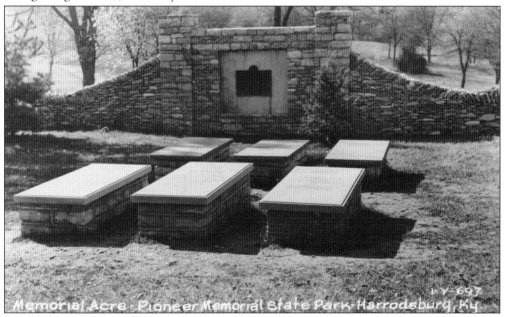

This 1940s card shows Revolutionary Acre, located adjacent to Pioneer Cemetery. At that time, it was under the supervision of the Kentucky division of the Daughters of the American Revolution. Remains of Revolutionary soldiers may be removed from old family cemeteries or other neglected spots and brought here. The memorials in the foreground are those of Revolutionary officer Capt. Lewis Rose, his wife, and son; they were dedicated in a ceremony attended by over 100 in the 1930s.

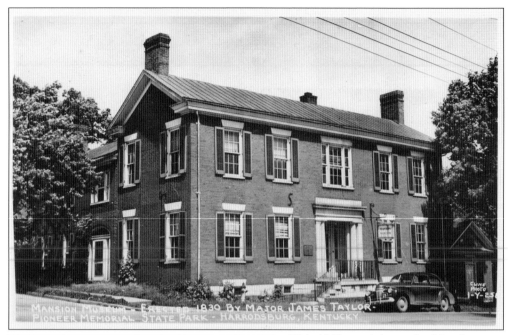

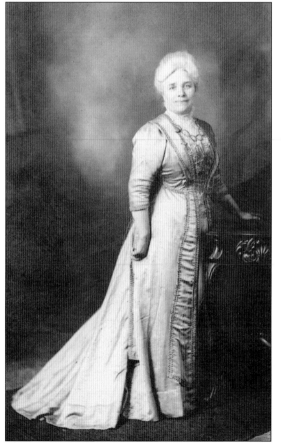

This 1940s card shows the Mansion Museum, a private home until it became the property of the Pioneer Memorial Association and later incorporated into Fort Harrod State Park. The land was acquired in 1830, and the house was built by Maj. James Taylor, who was prominent in the affairs of Harrodsburg. The house remained in the Taylor family for close to 100 years and was an integral part of Harrodsburg's social scene. The real–photo card at left is of Sarah Emily Taylor Moore when she was an older woman, probably in the late 1800s, as she died in 1894. She was the daughter of James Taylor and the wife of Colonel Moore. The once private mansion is now known as the Mansion Museum because it houses a remarkable collection of antiques and relics from pioneer days.

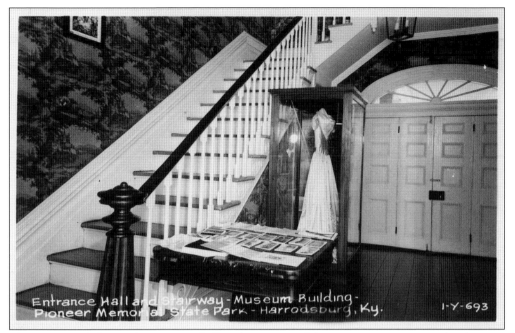

Entrance Hall and Stairway - Museum Building -
Pioneer Memorial State Park - Harrodsburg, Ky. 1-Y-693

This 1946 card shows the entrance hall and stairway of the Mansion Museum. The dress on display is Sarah Taylor's wedding dress from 1849. She was the daughter of builder and owner James Taylor, and the dress was donated by her daughter when the house became a museum. The furnishings of the museum were largely contributed by chapters and members of the Daughters of the American Revolution.

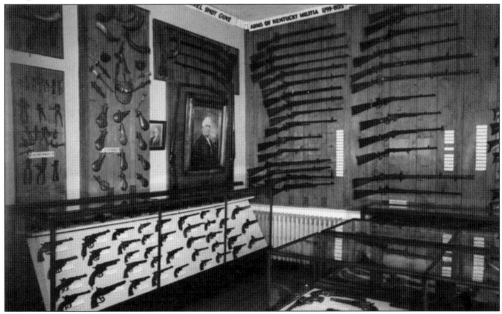

This chrome card, dating from the 1950s, shows the gun or weapons room in the Mansion Museum. It houses implements of Indian warfare, flintlock rifles of the long hunters, dueling swords, powder horns, and pistols. Most of these firearms were acquired by the Kentucky State Park Commission in 1930 for the sum of $4,500 from J.J. McIntosh.

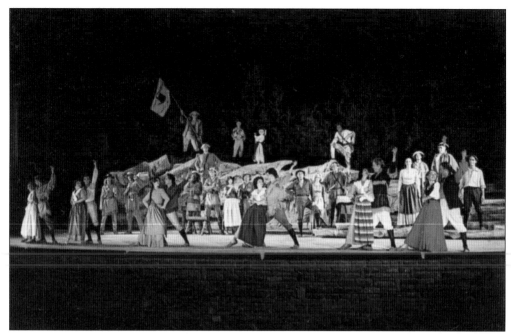

These two cards show scenes from the outdoor dramas produced at Fort Harrod from 1963 through 2004. In 1961, committee members from Harrodsburg met with the Kentucky parks commissioner and presented their completed request on information for the construction of an amphitheater and the production of a historical drama at Fort Harrod State Park. In 1962, Robert McDowell was hired to write the script for the premier production of *Home is the Hunter*. In 1966, *The Legend of Daniel Boone* replaced the original drama. In 1982, *Lincoln* was added on an alternating schedule. The final production in 2004 was *Daniel Boone—The Man and The Legend*. Outdoor dramas thrived in Kentucky from the 1960s through the 1980s. Today, there are only a few outdoor dramas remaining nationwide.

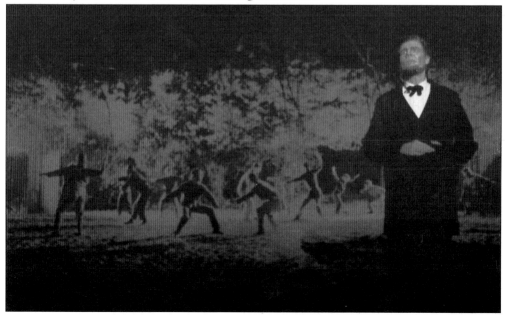

Two

HARRODSBURG

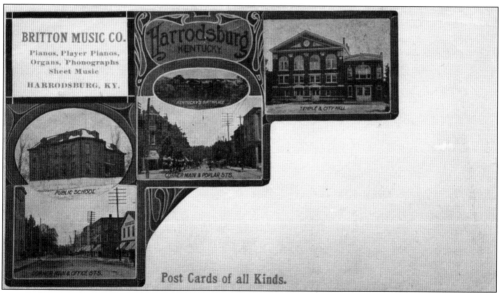

Postcards were published in Harrodsburg in the early 1900s by the Britton Music Company, in addition to its regular business of musical instruments and related supplies. Four early images of Harrodsburg have been printed on its business envelope as an advertisement. Local photographers, such as H.C. Wood or the Rue family, probably sold the company the rights to reproduce their work commercially as postcards. The business was located on Main Street in the current Harrodsburg Courthouse Annex Building.

Novelty postcards were very popular in the early 1900s. There are many generic postcards that are called "Greetings from" cards. Local publishers could buy them in quantity and then stamp in the name of the location. Some cards have glitter glued on the name to make it really special. This card was postmarked from Harrodsburg to Paducah, Kentucky, in 1908.

Another popular card was known as the "pennant" card. Its heyday was during the early 1900s, and this card was postmarked in 1918. There are 20 pennant cards in this collection, all with different messages. A sampling reads: "Lots of nice girls in Harrodsburg but none like you," "Am enjoying the sights in Harrodsburg–good lookers everywhere," and "Lovings great in Harrodsburg–how would you like to be here?"

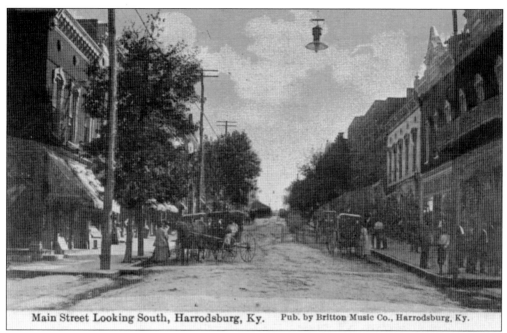

Main Street Looking South, Harrodsburg, Ky. Pub. by Britton Music Co., Harrodsburg, Ky.

Both of these cards are images of lower Main Street looking south and date to the early 1900s. The one above is addressed to W.W. Goddard from his sister "M," who is wishing him a "happy and prosperous New Year." The Goddards were a prominent Mercer County family. The card below is postmarked 1909, and its writer complains of having been to the dentist, feeling tough, nothing doing in town except circuit court, and ends on a happier note of a party. Both cards show the streets were unpaved, but electricity had arrived. Transportation was centered around the horse and buggy. The building in the card below with the stone archway was the Arcade Livery Stable, constructed in 1884. The building to its left was the Harrod Theater from 1940 to 1973 and is now the Ragged Edge Community Theater.

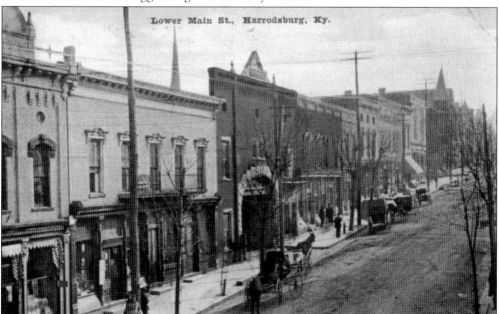

Lower Main St., Harrodsburg, Ky.

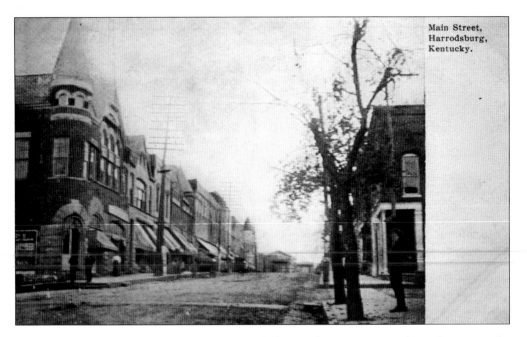

Main Street, Harrodsburg, Kentucky.

These two cards show the east side of the middle block of Main Street in the early 1900s. The card above is an earlier style done exclusively in black and white, and the card below is a hand-colored black-and-white photograph by local photographer and writer H.C. Wood. The corner building was the most impressive structure on the block, having a turret and large stone arches and stained-glass windows. It was built in 1884 in the Victorian Romanesque style and known as the Blue Front, named for the Blue Front department store located there. The upper floor was built in theater style and known as Chenoweth Hall. It was the site of much gay entertainment by traveling theatrical companies at the turn of the 20th century.

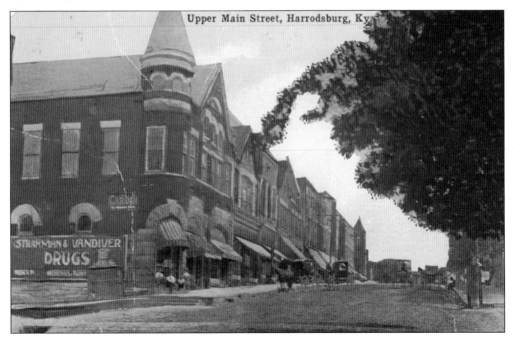

Upper Main Street, Harrodsburg, Ky.

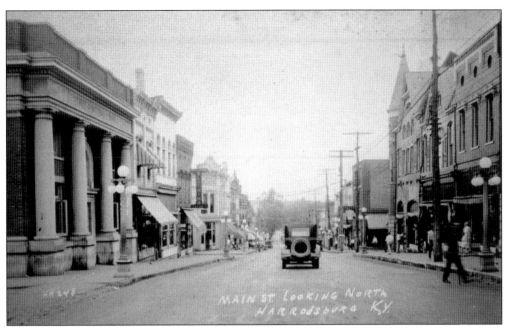

These two views are from the middle block of Main Street looking north. The above card is from the 1930s. Electricity, paved streets, and cars have replaced gas lamps, dirt streets, and the horse and buggy, which were all common only 20 years or so before. The impressive building on the left with its tall Doric pillars was constructed by the First National Bank in the late 1920s and serves presently as city hall. The building with the "clothing" sign on the left is now Sexton Real Estate. It is also the former site of Noel's Men's Shop and other clothing stores over some 50 years, from about 1914 to 1966. The card below is a 1940s real-photo postcard by Cline Photography. Main Street is in its heyday, as evidenced by the cars parked bumper-to-bumper, and is the heartbeat of the town.

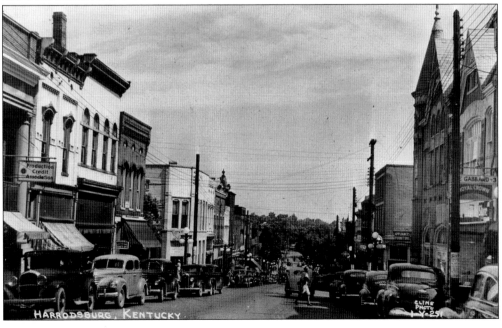

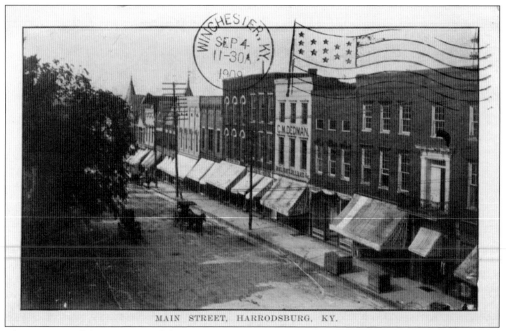

MAIN STREET, HARRODSBURG, KY.

These views of the east side of the middle block of Main Street are on postcards from the early 1900s. This block was the scene of two major fires—in 1857 and in 1914. Rebuilding of the block was swift after each fire. These buildings date from the 1860s to the 1890s. Awnings were installed on most storefronts to protect the merchandise from the sun and also to help keep the stores' interiors cool. The white-front building with the name C.M. Dedman on it was Dedman Drugstore (1890–1938), Stagg Drugstore (1938–1959), Botner Rexall Drugs (1959–1976), and McKinney Rexall Pharmacy (1977–1983). In the card below, the building on the corner was known as the James Flats and was one of the largest structures on Main Street. It had six businesses on the first floor and 12 apartments on the second and third floors.

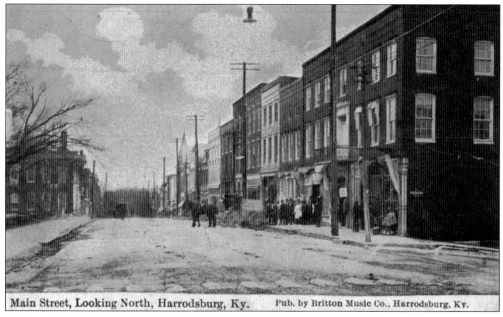

Main Street, Looking North, Harrodsburg, Ky. Pub. by Britton Music Co., Harrodsburg, Ky.

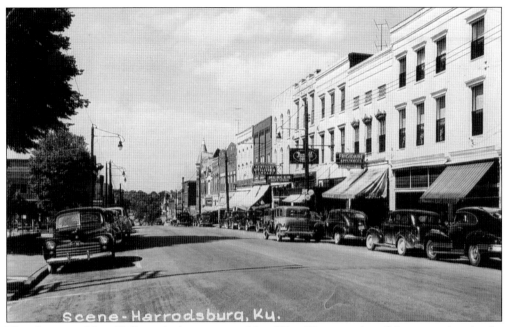

Scene - Harrodsburg, Ky.

The above card is a 1940s real-photo postcard by Cline Photography of the same view in the previous two cards. Cars are parked bumper-to-bumper, and black seems to be the popular color. Some storefronts still use awnings to protect and cool their stores. There have not been any major changes in the look of this block from earlier days. The courthouse square is across the street where the trees are.

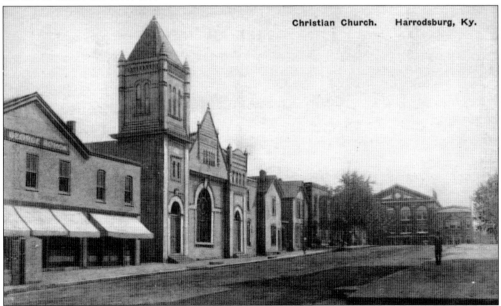

Christian Church. Harrodsburg, Ky.

This is a 1920s card published by the Music Supply Company of Harrodsburg, located in the Blue Front Building. On the left is the George Bohon Store, dating from 1876, and next to it is the old Harrodsburg Christian Church, built in 1848. Both were demolished in 1926 to make way for a new Christian church building. On the right is the Odd Fellows Lodge, built in 1905.

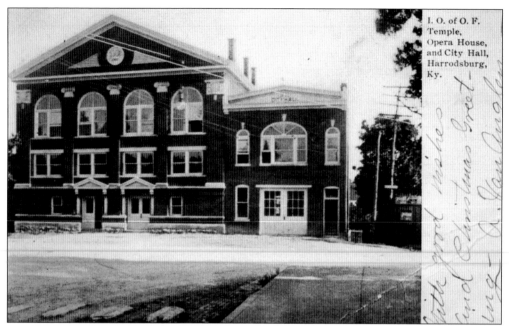

Constructed in 1905 with the Independent Order of Odd Fellows insignia on its front, this building was the opera house and city hall complex. For 20 years after it was built, silent movies were shown there with a piano player to provide music. From 1933 to 1951, it served as the meeting hall for Montgomery Lodge No. 18. The attached two-story building was city hall.

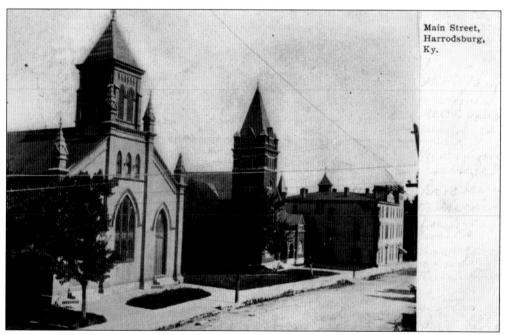

An early-1900s view of the west side of South Main Street shows the United Presbyterian Church on the left, the Baptist church, and the Hotel Harrod on the right. The Presbyterian church was built in 1853. The Baptist church was in use from 1900 to 1961, and the hotel was demolished by the Baptists in 1959 to make way for a new building.

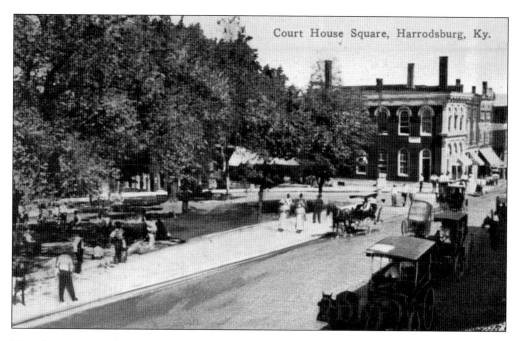

The above card, dated 1917, shows the courthouse square located on the west side of Main Street between Short and Office Streets. The area was once known as the "woods on the hill" because of its many trees, which had not yet been cut down. The message on this card refers to the scene as "one of our noted parks." The original courthouse square was much larger than now, extending over to Poplar Street. There was room for the courthouse, a separate county clerk's building, jail, market house, and stray pens to hold livestock, which had wandered from home. The real-photo card below dated November 1908 shows the same scene as in the above card and reads, "This is county court day in Harrodsburg, Monday, November 2, the day before presidential election. I took this with my Kodak."

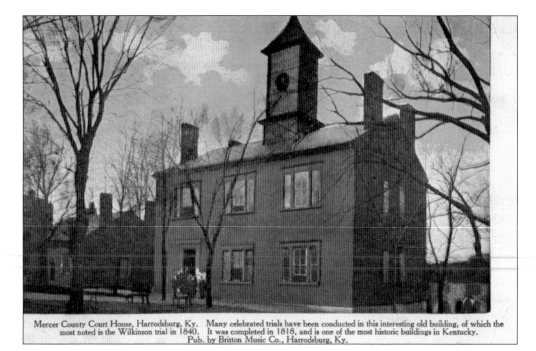

Mercer County Court House, Harrodsburg, Ky. Many celebrated trials have been conducted in this interesting old building, of which the most noted is the Wilkinson trial in 1840. It was completed in 1818, and is one of the most historic buildings in Kentucky.
Pub. by Britton Music Co., Harrodsburg, Ky.

The above shows the courthouse and smaller clerk's buildings on a card produced by Harrodsburg's Britton Music Company. This courthouse was in use from 1818 until 1912. It was Harrodsburg's first courthouse of which there is any visual image. It was the scene of many celebrated trials, provided space for Harrodsburg's first public library, and, in 1873, was the site of a courtroom killing of three members of the Daviess family. The card below shows a photograph by H.C. Wood of the 1912 to 1929 courthouse. The card was postmarked 1917 and addressed to Harrodsburg resident Ben Smock, who was in Louisiana at the time, from his wife "Pet" and speaks of "going to the Opera House for the first series of Lyceum courses."

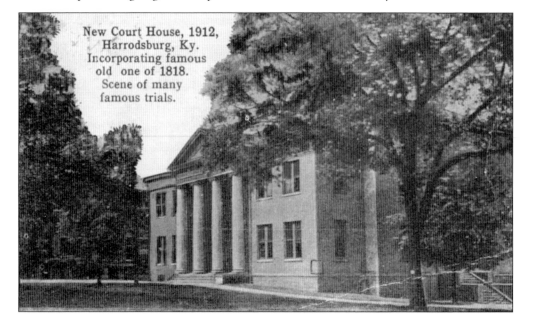

New Court House, 1912, Harrodsburg, Ky. Incorporating famous old one of 1818. Scene of many famous trials.

This card advertises the laying of the cornerstone for the 1912 courthouse, shown on the previous page. The cornerstone is visible just above the foundation on the corner nearest the first-floor double windows. It contained a small copper box with close to 100 pieces of memorabilia in it. The cornerstone and its contents are on display in the new Harrodsburg Judicial Center.

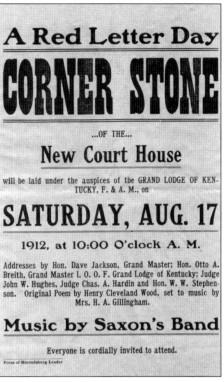

A Red Letter Day

CORNER STONE

...OF THE...

New Court House

will be laid under the auspices of the GRAND LODGE OF KENTUCKY, F. & A. M., on

SATURDAY, AUG. 17

1912, at 10:00 O'clock A. M.

Addresses by Hon. Dave Jackson, Grand Master; Hon. Otto A. Breith, Grand Master I. O. O. F. Grand Lodge of Kentucky; Judge John W. Hughes, Judge Chas. A. Hardin and Hon. W. W. Stephenson. Original Poem by Henry Cleveland Wood, set to music by Mrs. H. A. Gillingham.

Music by Saxon's Band

Everyone is cordially invited to attend.

Press of Harrodsburg Leader

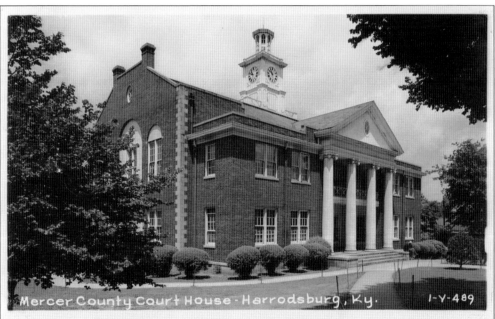

This is a 1940s Cline Photography real-photo postcard. This courthouse was built in 1929 and served 80 years until 2009, when it was demolished in spite of impassioned pleas from local citizens. An excerpt from *The Last Days* by Ethel Hamm reads, "I have heard rumors they are going to tear me down–today they took my windows and doors–I felt like crying but my eyes were gone."

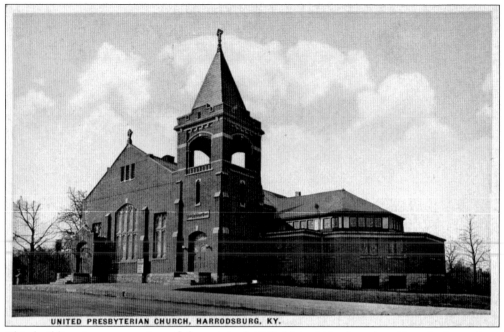

UNITED PRESBYTERIAN CHURCH, HARRODSBURG, KY.

This building is an expansion of the original 1853 United Presbyterian Church, located on South Main Street. The facade was remodeled, a new bell tower was erected on the corner of the church, and a multistory addition was constructed. This card shows the church that was in use from 1913 until 1965, when remodeling removed the side addition and expanded the church to the rear.

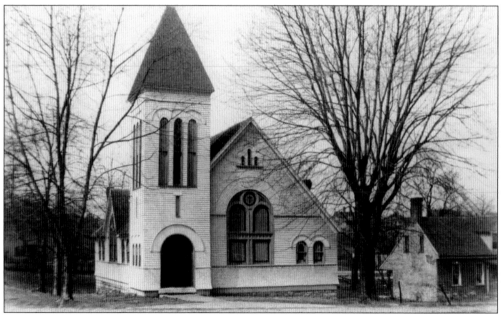

This card from the 1940s shows St. Andrew Catholic Church as it looked from 1893 until 1975, when this Romanesque-style building was replaced with a modern brick one, which served parishioners until the church was relocated outside of town in 2001. The building to the right was constructed in 1795 and served as a convent until it was demolished by the Baptists in 2003.

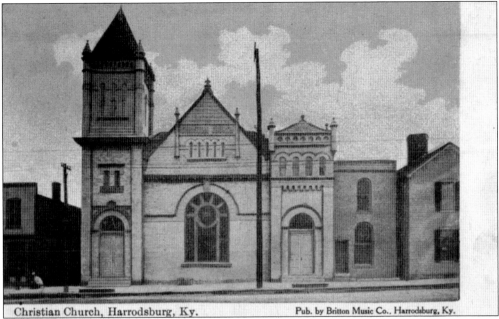

Christian Church, Harrodsburg, Ky. Pub. by Britton Music Co., Harrodsburg, Ky.

The card above is an early-1900s view of the Romanesque-style Christian church as it looked from 1848, when it was built, until 1926, when a new structure replaced it. When the Christian church was first organized in Harrodsburg, its members had no house of worship of their own. The nearby Union Meeting House served several denominations that jointly owned it and shared meeting space. The Christian church used it on an appointed Sunday each month and on the other Sundays held services at the courthouse. The card below is a 1950s view of the present church, built in 1926 in the Colonial Revival style. In order for the church to expand, the building on the corner lot housing the George Bohon Company farming supplies and carriages was torn down.

Christian Church - Harrodsburg, Ky. 1-Y-336

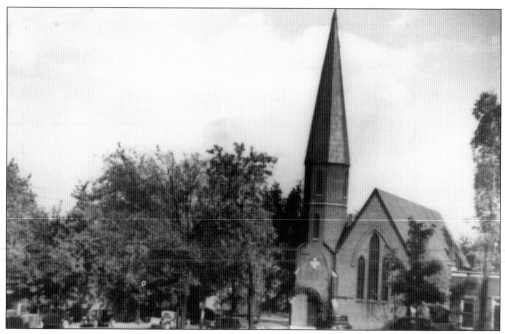

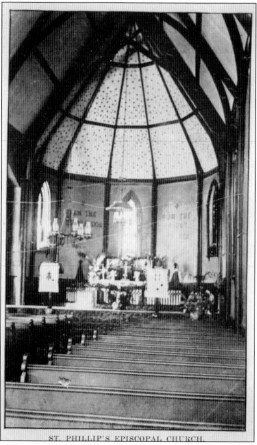

ST. PHILLIP'S EPISCOPAL CHURCH.

These two cards from the 1940s show exterior and interior views of St. Philip's Episcopal Church. The cornerstone was laid in 1860, and the church was dedicated in 1861. The English Gothic–style building was designed by Benjamine Bosworth Smith, the first Episcopal Bishop of Kentucky, after a church he had visited in England. This is the only church in Harrodsburg still meeting in its original building. A famous event in St. Philip's history occurred on October 9, 1862, the day after the Battle of Perryville. Gen. Leonidas Polk, CSA, "the fighting Bishop," retreating with his troops to Harrodsburg, saw the church doors open and asked that the bell be rung. He led a prayer for the North as well as the South and asked for "peace to the land and blessing on friend and foe alike."

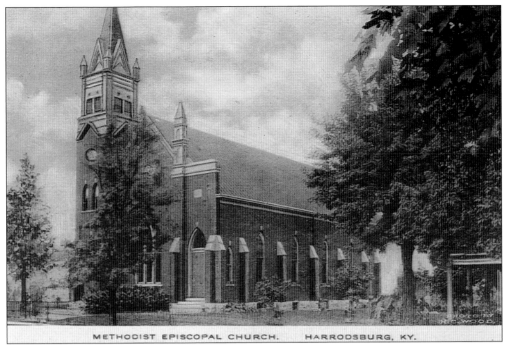

METHODIST EPISCOPAL CHURCH. HARRODSBURG, KY.

The above card shows the first church of the Methodist congregation, built in 1840 and called the Methodist Episcopal Church. Local photographer H.C. Wood made the image. Three successive church buildings have occupied the same corner lot—from 1840 to 1889, from 1889 to 1940, and from 1940 to the present. Handmade bricks were used for the first building, and the churchwomen donated coin silver and other silver pieces to be used in the casting of a bell that would have an especially sweet tone because of the silver. The 1940s card below is of the 1940 church, now called the Harrodsburg Methodist Church and built in the same Gothic Revival style as the earlier ones. The sermon topic listed in a 1941 church bulletin was "The Devil's Business in Harrodsburg and Who Attends to It," which is probably still timely some 70 years later.

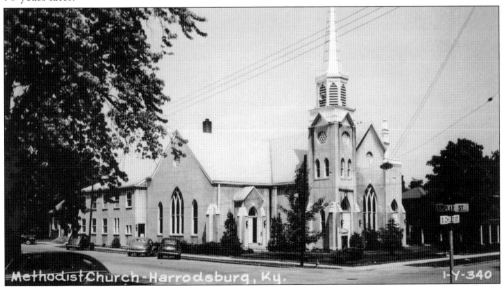

Methodist Church-Harrodsburg, Ky. I-Y-340

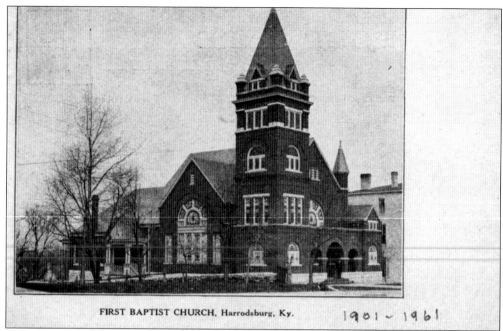

FIRST BAPTIST CHURCH, Harrodsburg, Ky. 1901 ~ 1961

The above postcard is of the first Harrodsburg Baptist Church, in use by the congregation from 1900 until 1961. Church minutes from July 18, 1899, report that the architect is requested to furnish plans for the new church "to cost not over $12,000 complete and furnished and ready for occupancy." The final cost was $15,700.93. The dedication was reported as "a grand affair," and the *Louisville Courier-Journal* called the new church "the town's finest building and a monument to the enterprise of its pastor and congregation." The below card shows the sanctuary as it would have looked during the 1920s and 1930s, adorned with many ferns, palms, and other large plants, as was the custom of that era.

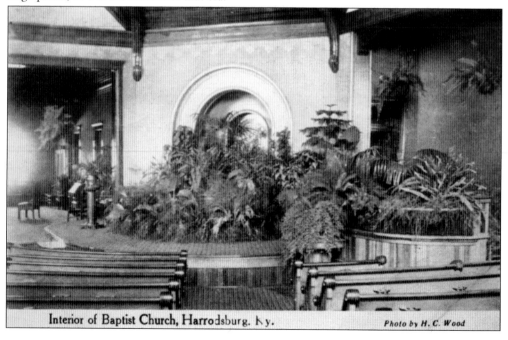

Interior of Baptist Church, Harrodsburg, Ky. Photo by H. C. Wood

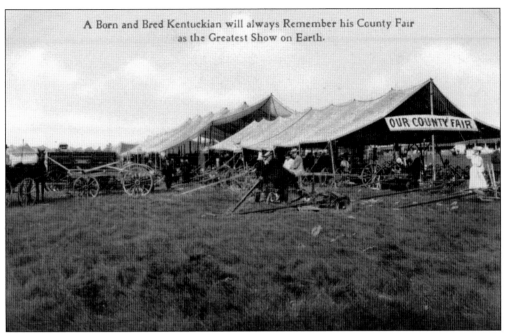

A Born and Bred Kentuckian will always Remember his County Fair as the Greatest Show on Earth.

OUR COUNTY FAIR

This card celebrating county fairs in general was published by the Kramer Art Company of Cincinnati, Ohio, in the early 1900s. It was part of its American Special Series Art Cards, printed in Germany, which were considered some of the best-quality ones of their time. County fairs were as American as apple pie, and it was rare to find a county seat that did not try to outdo the neighboring counties.

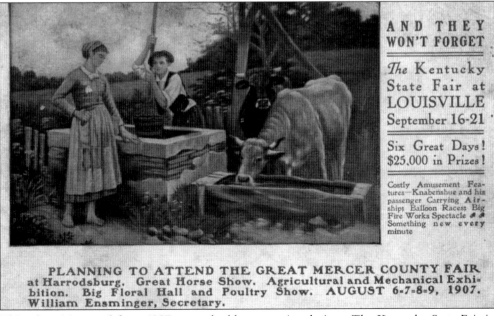

AND THEY WON'T FORGET

The Kentucky State Fair at LOUISVILLE September 16-21

Six Great Days! $25,000 in Prizes!

Costly Amusement Features—Knabenshue and his passenger Carrying Airship; Balloon Races; Big Fire Works Spectacle ✦ ✦ Something new every minute

PLANNING TO ATTEND THE GREAT MERCER COUNTY FAIR at Harrodsburg. Great Horse Show. Agricultural and Mechanical Exhibition. Big Floral Hall and Poultry Show. AUGUST 6-7-8-9, 1907. William Ensminger, Secretary.

This advertising card from 1907 was a double promotional piece. The Kentucky State Fair in Louisville produced this card to advertise its fair, but there was also space at the bottom for local fairs to print their information. The four-day Mercer County Fair is promoting its great horse show, agricultural and mechanical exhibits, big floral hall, and poultry show in August.

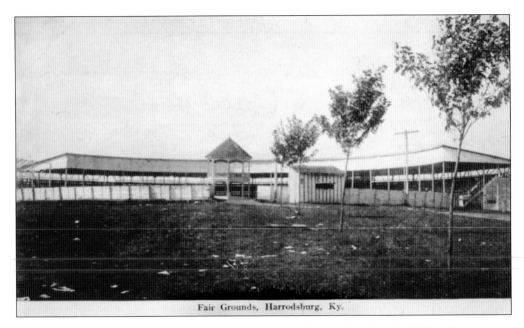

Fair Grounds, Harrodsburg, Ky.

The above card shows the Mercer County Fairgrounds sometime in the 1920s. The Mercer County Fair and Horse Show began in 1828 and was held continuously each year from 1833 on. County fairs were actually preceded by competitions as far back as Fort Harrod and Boonesboro, when the settlers would blow off some steam and challenge each other to horse races. The Mercer County Fair and Horse Show is billed as "the oldest continuous fair and horse show in the country," having survived the Civil War, World Wars I and II, the Depression, and numerous other hardships without missing a year. In the card below, a horse show scene from the early 1900s is seen. The show ring was circular and had a center ring pavilion for judges and officials. The early grandstand only surrounded half of the show ring.

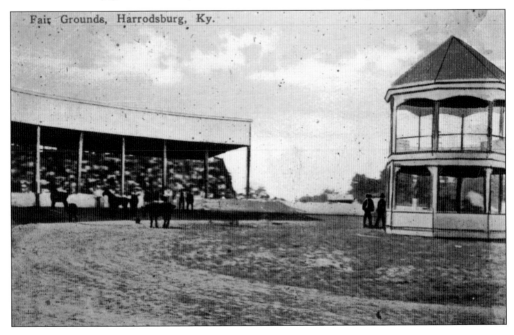

Fair Grounds, Harrodsburg, Ky.

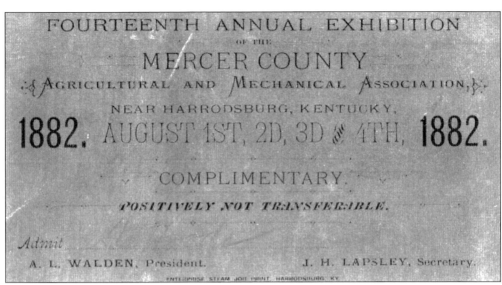

FOURTEENTH ANNUAL EXHIBITION
OF THE
MERCER COUNTY
Agricultural and Mechanical Association,
NEAR HARRODSBURG, KENTUCKY,
1882. AUGUST 1ST, 2D, 3D & 4TH, 1882.

COMPLIMENTARY.

POSITIVELY NOT TRANSFERABLE.

Admit

A. L. WALDEN, President. J. H. LAPSLEY, Secretary.

ENTERPRISE STEAM JOB PRINT, HARRODSBURG, KY.

This is an example from 1882 of a complimentary card to admit Archibald G. Woods to the Mercer County Agricultural and Mechanical Association exhibition. County fairs were the eventual result of agricultural societies formed for the improvement of livestock and crops. Fayette County had the first fair and cattle show in 1816. By 1828, there were 26 agricultural and mechanical societies, and Mercer County's was among them.

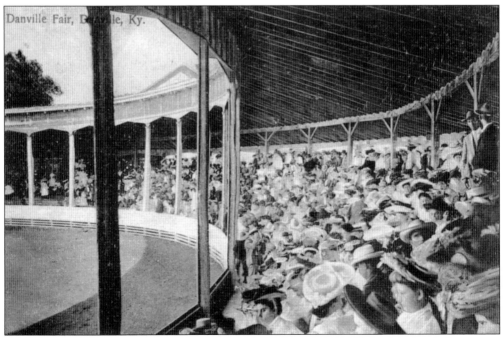

Danville Fair, Danville, Ky.

This was a generic-style card featuring a packed grandstand at a county fair. The name of the location could be imprinted in the corner of whichever town was being advertised. This one has Danville, Kentucky, printed on it, but it could just as well be Harrodsburg, as that is what its grandstand looked like.

The above 1950s view of the Old Fort Motel brings back memories of home-style accommodations prevalent in the 1930s and 1940s. The motel was built by William Bailey, father of the late Jack Bailey, in the 1940s and was located on South College Street across from Fort Harrod. On trips to Florida, William Bailey had lodged at similar places and thought that would be a good idea to try in Harrodsburg. He advertised six modern units, combination tub and shower, air-conditioning, and television. The postcard below is of the Gaskins Motel, which was also located on South College Street, next to Old Fort Motel. It advertised Beauty Rest beds, tile baths, and air-conditioning. In the next block was Stones Motel, a similar type of lodging. The reason for so many small motels springing up at this time was there were a lot of traveling salesmen who could fill the rooms nightly.

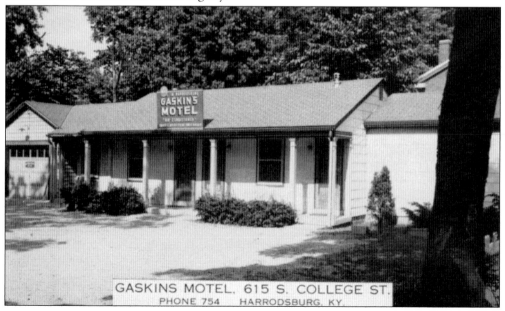

GASKINS MOTEL, 615 S. COLLEGE ST.
PHONE 754 HARRODSBURG, KY.

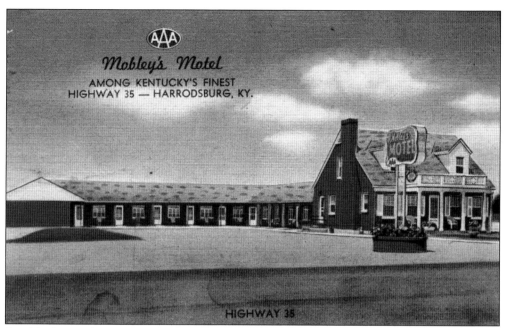

Mobley's Motel
AMONG KENTUCKY'S FINEST
HIGHWAY 35 — HARRODSBURG, KY.

HIGHWAY 35

"Mobley's Motel is Among Kentucky's Finest" is the headline of a June 27, 1952, *Harrodsburg Herald* article on the new motel completed here by Hollis Mobley. Mobley was a Mercer County native and businessman who also ran a local tobacco warehouse. The above card shows the new 14-unit brick complex, located on what was then Highway 35 but is now variously known as North College Street, Louisville Road, or US 127. While traveling, Mobley had seen more modern motels being built and wanted to construct his own in Harrodsburg. It advertised central heat and air-conditioning, tile baths, showers, Simmons furniture, and Beauty Rest mattresses, giving the lodging a AAA rating. The Mobley family lived in separate quarters attached to the motel. The card below shows the same motel sometime in the 1960s, when it had been bought by William Bailey, who also started the Fort Harrod Motel.

Bailey's Motel
Among Kentucky's Finest
Highway 127 - Harrodsburg, Ky.

This 1960s chrome postcard of the Town House Motel shows a modern brick building, constructed by Carl and Roy Campbell in the 1950s, located on busy South College Street or US 127. At this time, Mr. and Mrs. C.A. Akers were the owners-managers of the 10 modern rooms with tile baths, steam heat, air-conditioning, and televisions, and they offered family rates. The motel has since been converted into apartments.

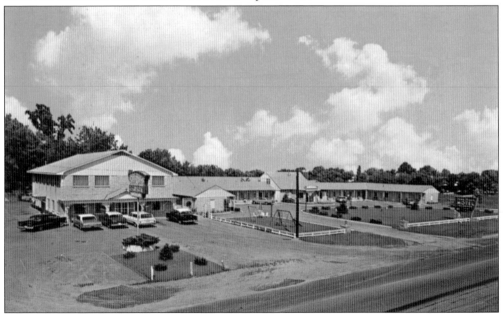

This card shows the Stone Manor Motel and Restaurant in the 1960s. It was advertised as "one mile south on State 127, in a quiet location, with 30 nicely furnished air conditioned units in a stone motel, with central heat, combination tile baths, connecting and two room units, and cribs." The restaurant was owned and operated by Mr. and Mrs. M.B. Hall. Both businesses were demolished in 2006 or 2007.

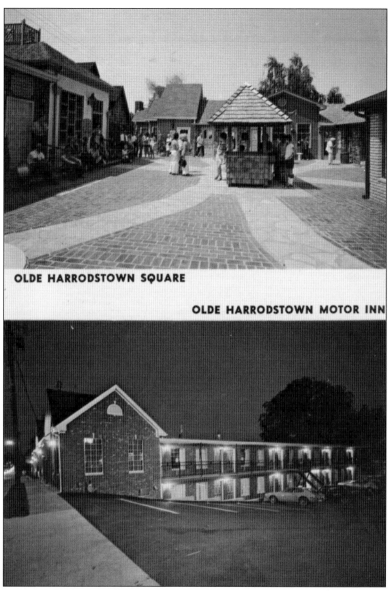

OLDE HARRODSTOWN SQUARE

OLDE HARRODSTOWN MOTOR INN

Andrew Armstrong Photography took the photographs displayed on this split-image chrome card from the 1970s, which features Olde Harrodstown Square and Olde Harrodstown Motor Inn, located on South College Street. An article in the *Harrodsburg Herald*, dated May 24, 1973, details the changes that were coming to buildings on this block facing South College Street and adjacent properties between West Poplar and West Office Streets. These properties were one- and two-story frame structures, housing businesses like Vernetta Parrish Antiques and Stone's Motel. The Harrodstown complex was advertised as a "charming reflection of yesteryear, featuring a new modern 38 unit motor inn, restaurant, and art and craft shops, all within walking distance of Fort Harrod, downtown Harrodsburg, and many other historical points of interest." It was built by the Old Harrodstown Corporation with the intent of providing tourists with more opportunities to "visit, buy, eat, sleep, browse, rest, and linger" and also with the hope that it might be one of the "greatest assets to Mercer's tourist trade." Its potential was never realized, and it sits empty most of the time.

Kentucky's First Tavern

Erected in 1787

The old tavern was torn down in 1882 and the present building of the Mercer National Bank then erected. Among the N_tion's famous men who have been sheltered in this famous old hostelry are: James Harrod, Daniel Boone, Isaac Shelby, Abraha_ Lincoln, Aaron Burr, Henry Clay, Marquis de Lafayette, Andrew Jackson, Zachariah Taylor, John J. Crittenden, Franklin Pierc_ Jefferson Davis, Admiral Jouett, James Guthrie, Amos Kendall, Wm. T. Barry.

The Wingfield Tavern was originally built in 1787 as a log structure and was the first tavern in the oldest town in Kentucky. It was located on the corner of South Main and West Poplar Streets. Records report it was granted a tavern license in 1791. In 1800, the logs were sided over, and it was repaired and enlarged. The ground floor was used as the combination bar, eating area, and billiards room and had a large fireplace. Sleeping rooms were located on the second floor. In 1825, General Lafayette was entertained at the tavern and, according to legend, lost a game of billiards with local champion player Dickie Figg. It was also here that Aaron Burr, General Adair, and Colonel Meaux held their celebrated meeting to plan securing the Louisiana Territory for the United States. Other famous men who passed through the doors were James Harrod, Daniel Boone, Isaac Shelby, Abraham Lincoln, Henry Clay, Andrew Jackson, and Jefferson Davis. After 95 years of being the center of historic events in Harrodsburg, the tavern was demolished in 1882 to make way for the new Mercer National Bank Building.

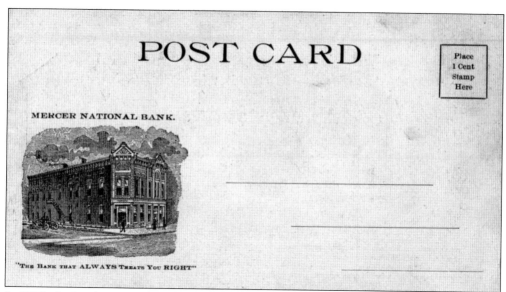

POST CARD

MERCER NATIONAL BANK.

"The Bank that ALWAYS Treats You RIGHT"

In 1882, the handsome brick-front Mercer National Bank Building was constructed on the site of the old Wingfield Tavern, which had been demolished after 95 years of providing a space for history to be made in Harrodsburg. In 1885, the building was destroyed by fire, but everything in the vault was saved. A larger and safer building was immediately begun on the same site.

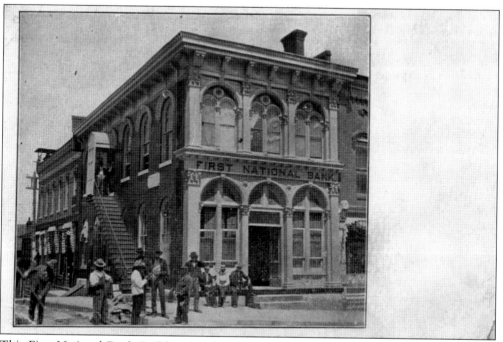

This First National Bank Building on the corner of South Main and Short Streets was built around 1871 and had to be one of the most attractive in town at that time. This bank was the scene of an infamous attempted bank robbery during the Civil War. Sue Munday and Sam "One-Armed" Berry were part of a group that attempted to rob this bank in 1864, which resulted in a shoot-out on Main Street.

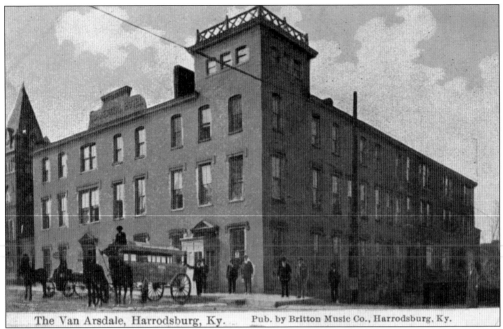

The Van Arsdale, Harrodsburg, Ky. Pub. by Britton Music Co., Harrodsburg, Ky.

These two postcards show a hotel, built in the 1850s, which remained virtually unchanged in appearance through its close to 100-year history. The card above is from the early 1900s, when the hotel name was the VanArsdale. The card below is from the 1940s, when it was the Avalon Inn. It was situated on the southwest corner of Main and West Office Streets. This location had been the site of Old Stone Tavern, dating from the late 1700s, and also of a series of hotels since Harrodsburg's founding until 1959, when the Baptist church demolished the structure depicted. Through the years, it was home to both residents and transient guests and had a dining room noted for fine Southern food. It was "the place" to have Sunday lunch after church in the 1940s and 1950s. During its lifetime, it was known by various names, such as Commercial Hotel, National Hotel, and Hotel Harrod.

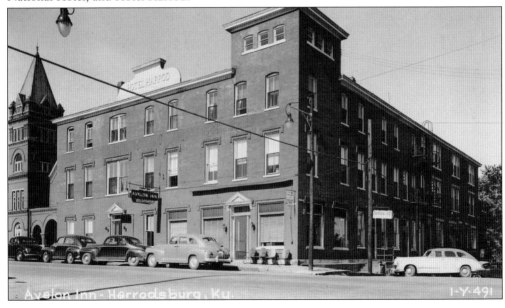

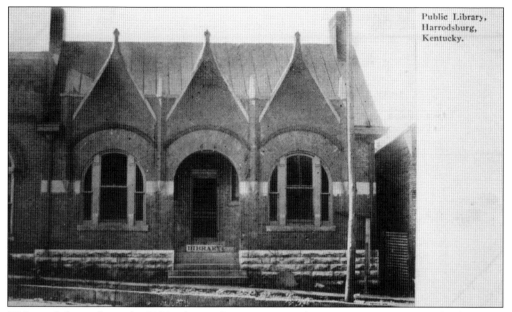

Public Library, Harrodsburg, Kentucky.

This card from the early 1900s shows the very unusual Victorian Romanesque building on West Poplar Street, which housed the public library from 1911 to 1965, when it moved to a restored section of Morgan Row. This was the third location for the library, which started in the old courthouse, then in 1895 had one room in the James Flats building, and, in 1911, bought this property.

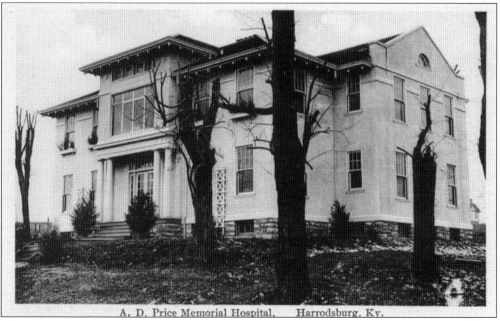

A. D. Price Memorial Hospital, Harrodsburg, Ky.

The A.D. Price Memorial Hospital was built in 1915 and dedicated in remembrance of the contribution of Dr. Ansel Daniel Price. A quote from the *Harrodsburg Herald* says of Price that he is "one of the most universally loved men who ever lived in our community and a widely known physician in central Kentucky." This 20-bed hospital served for 34 years until a larger one was needed, and built in 1949.

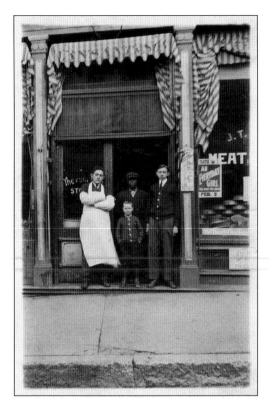

This is a real-photo postcard from the early 1900s of J.T. Ingram's grocery store on the east side of South Main Street in the building that later housed the Gem Drugstore. Ingram operated here from 1896 to 1901 and then moved across the street in 1902. It appears he ran a grocery business for close to 20 years. During this period, from 1896 to the 1920s, there were approximately 15 groceries, bakeries, or confectioneries located on Main Street, with most being in the blocks from Lexington to Poplar Streets. This card below shows what looks to be a rather high-class establishment known as the Old New Era Restaurant, which operated from approximately 1905 to 1911 on Main Street at the site of the present Old Towne Park. An advertisement reads, "We intend to conduct the business on a high plane."

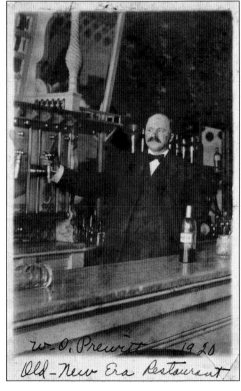

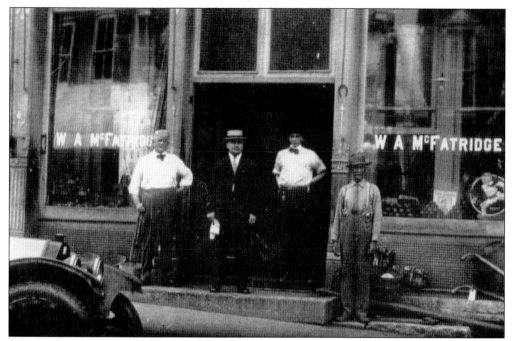

This real-photo postcard, postmarked 1909, is of William Andrew McFatridge, owner of a hardware, paint, and grocery store found at the same location as J.T. Ingram's store on South Main Street. McFatridge is the man in the suit and hat in the middle, flanked by unidentified employees.

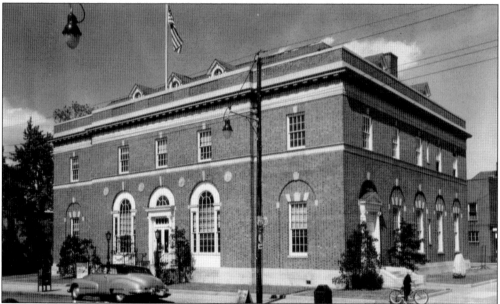

This real-photo postcard by Cline Photography shows the Harrodsburg Post Office, probably in the early 1950s. The post office opened its doors to Harrodsburg in 1932. The town owes a debt of gratitude to some residents who were concerned about how the new building would fit into its historic surroundings. They convinced the officials to design a Colonial-style building that would conform to the age and style of the town.

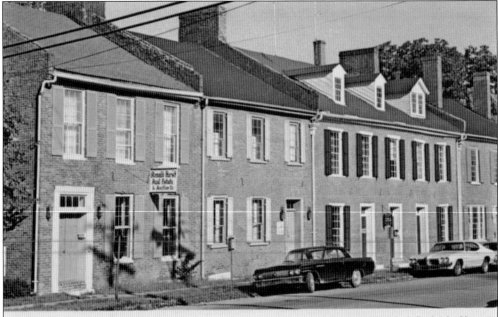

Morgan Row - Built early 1800's. First row house in Kentucky, it contains the Historical Society's Museum and the Public Library.

These two cards are of Morgan Row. The one above is part of a Historic Harrodsburg folder, and the card below is a drawing by the late local artist Ruth Beall. The purchase and restoration of Morgan Row was started in 1964, under the direction of the Harrodsburg Historical Society. This Federal-style four-unit row house on Chiles Street is reputed to be the oldest one in Kentucky. It was built by Joseph Morgan during a period from 1807 to 1830 and named in his honor. Chiles Street bears the name of Morgan's son-in-law John Chiles, who ran a famous tavern there and operated stagecoaches and US mail routes from this hostelry. Morgan Row was the social and business center of Harrodsburg in the early to mid-1800s. The interior has woodwork attributed to the well-known craftsman Matthew Lowery.

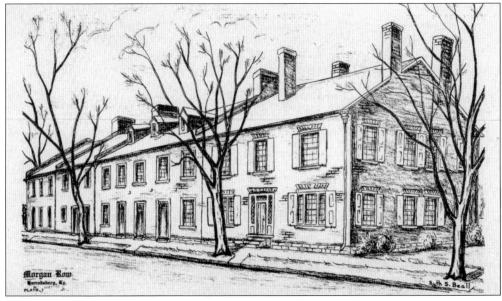

Morgan Row
Harrodsburg, Ky.
PLATE 1

Ruth S. Beall

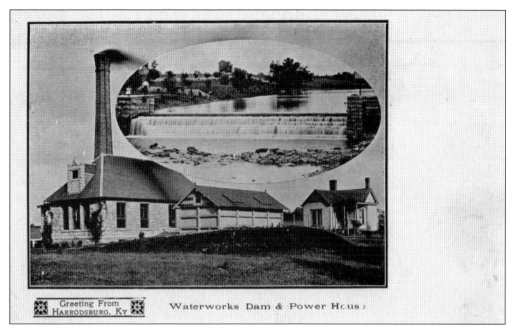

Greeting From HARRODSBURG, KY

Waterworks Dam & Power House

These two cards from the early 1900s show the Harrodsburg Water Plant and waterworks dam located on Mackville Road at Salt River. Photographs taken in the 1930s show a mill and mill dam located a short distance above the water supply dam. The late 1800s brought an improvement in living conditions for residents in Harrodsburg in the form of electricity in 1890 and a water system in 1893. The Kentucky Water, Heating & Illumination Company built the impressive stone pump house and dam and a water supply system—available for residences, businesses, firefighting, and street cleaning—ushering in a new era of sanitation. It is possible the building stone was obtained from the rock quarry that had been blasted out in the 1890s at the original Fort Harrod site just a few miles away.

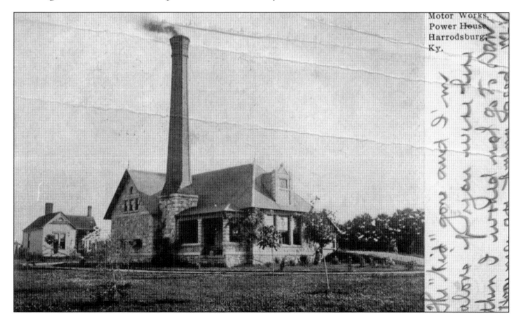

Motor Works, Power House Harrodsburg, Ky.

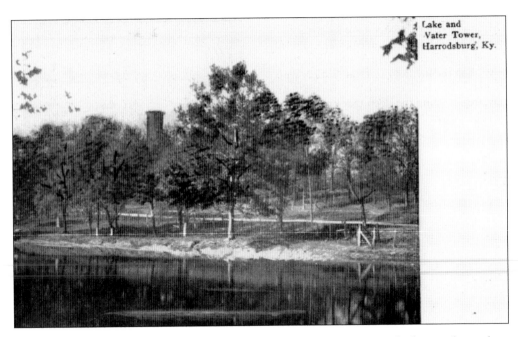

The above card from the early 1900s is of the lake and water tower, which were located on the east side of Chestnut Street in the area of the Chestnut Street Apartments. In 1828, Dr. Christopher Columbus Graham, owner of the famous Graham Springs, took a 40-acre tract of that property and beautified it with water features and hundreds of unusual plants from around the country. A quotation reads, "A small and beautiful lake, 900 feet long, 300 feet wide and 15 feet deep, lately excavated, is well stocked with fish of the finest flavor, and its glassy surface enlivened by the presence of many wild and tame water fowls." The card below is of a drawing of the property showing the lake as the long oval on the left. The lake was drained sometime in the late 1950s or early 1960s.

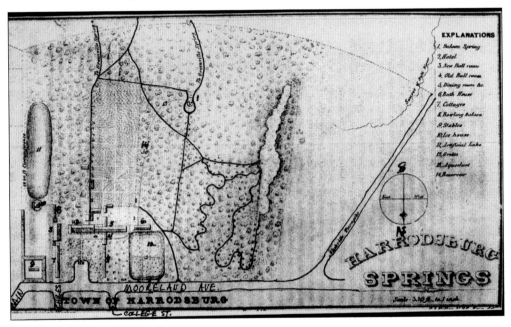

This impressive Confederate monument stands just inside the entrance to Spring Hill Cemetery in Harrodsburg. It was dedicated in 1902 to the memory of local soldiers who died for "the cause," where 97 who wore the gray are "sleeping the sleep that knows no waking." Over 200 visiting Confederates and their families were fed on the grounds by the Daughters of the Confederacy.

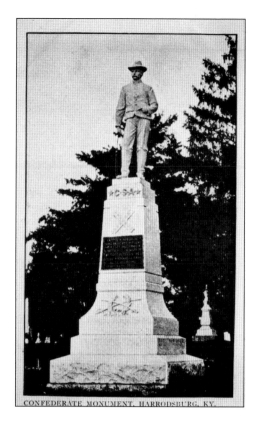

CONFEDERATE MONUMENT, HARRODSBURG, KY.

WHEN A MAN IS IN HIS GRAVE.

(By Henry L. Gibbs, Candidate for County Clerk.)

If you have any flowers to give to a friend
Just give them to him now,
Don't wait until he's beneath the sod,
When death's upon his brow,
But speak a kind word, 'twill help him along,
And teach him to be brave,
For flowers you know will do no good
When a man is in his grave.

If you have a neighbor you know is all right,
Speak up and tell him so,
For a kind word spoken when we're on earth
Is worth all that is said when we go,
Be a friend to a man is all that is asked;
Many sorrows by this you may save;
It's better than all the good things you may say
When a man is in his grave.

If you have any money you think you can spare,
Help some poor soul in need,
For then you are building a home over there
By doing that kind of a deed.
Don't wait until you've come to die
To give away dollars you've labored to save,
For remember that dollars will do no good
When a man is in his grave.

Don't look down on a man who's in hard luck
If he can't dress as fine as you,
For remember that "clothes don't make the man"
Is an adage you'll find to be true.
Though fortune has dealt unkindly with him
And he had no chance to save,
For the rich and the poor will be the same
When a man is in his grave.

There's a home up there where sweet angels dwell,
Where a man receives his reward,
And the good things you do while here on earth,
Are commendable in the eyes of our Lord.
So think of the things you might have done,
Of some poor soul you may save,
You'll find if you wait the time has passed
When a man is in his grave.

This is an unusual political card from 1917 that asks locals to vote for Henry Gibbs for county clerk of Mercer County. It also contains a poem written by him, which speaks of being a nice person, possibly in hopes the voter will think Gibbs is a nice person and vote for him. He did win that election.

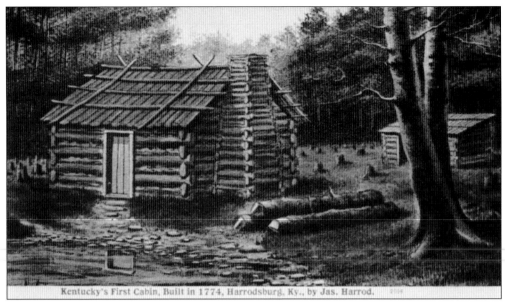

Kentucky's First Cabin, Built in 1774, Harrodsburg, Ky., by Jas. Harrod.

Although the postcards on the next pages show Federal-style and Greek Revival–style houses, it would be a mistake to assume the majority of houses in Harrodsburg were like these. There is a great variety of architectural styles to be found locally. Many houses started out as log cabins, as seen in the card above. Log houses continued to be built in Mercer County until the mid-1800s. It was only during remodeling or demolition that many homes were discovered to have a core log structure beneath the brick or weatherboarding. Shown below is Woodsland, thought to be the oldest house in Harrodsburg. Archibald and Anne Woods, who were one of the first families in Harrodsburg, built it between 1810 and 1820. The original four acres supplied the lumber, and bricks were fired on the site.

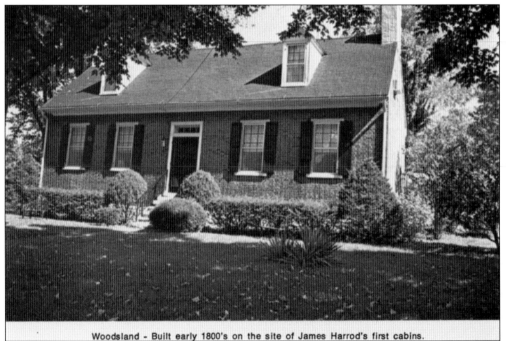

Woodsland - Built early 1800's on the site of James Harrod's first cabins.

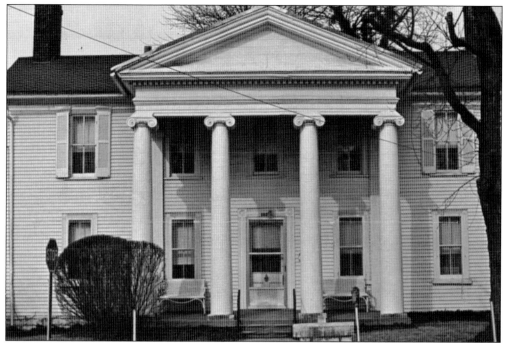

This card features Cardwellton, named after the Cardwell family who owned it at one time. It is situated on an original in-lot of Harrodsburg. Possibly as early as 1786, a log cabin was built, which became the nucleus for the later frame house built between 1831 and 1837. The house contains woodwork attributed to Matthew Lowery. It was once home to Dr. John Slaven, a faithful doctor during the cholera epidemic of 1833.

Alexandria was constructed in 1843 by Col. Richard Sutfield, a builder of several fine houses in Harrodsburg, including Courtview, just north of here. Sutfield was a soldier in the War of 1812 and a town trustee. Alexandria is an example of the classic Federal style with a Greek Revival portico, or porch.

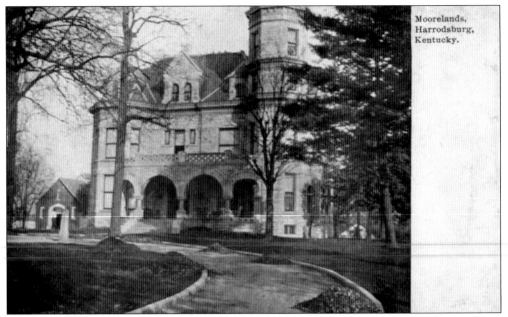

Moorelands,
Harrodsburg,
Kentucky.

Construction of Mooreland House began in 1891 and took five years to complete at a cost of $50,000. Its builder, Daniel Lawson Moore, was a Harrodsburg native and a descendant of an old and influential family of the South. The house was built as a wedding gift for his second wife, Minnie Ball of Woodford County. The architect of this impressive mansion is unidentified, but it can match the quality of similar grand houses of this style anywhere in the country. There are 17 rooms on two floors, which display a variety of stained-glass windows, parquet floors, and elaborate plasterwork. The card below shows the house sometime in the 1940s and is from Moore's daughter Minnie, who spent her life there, to a friend in Paris, Kentucky, thanking her for a recent party.

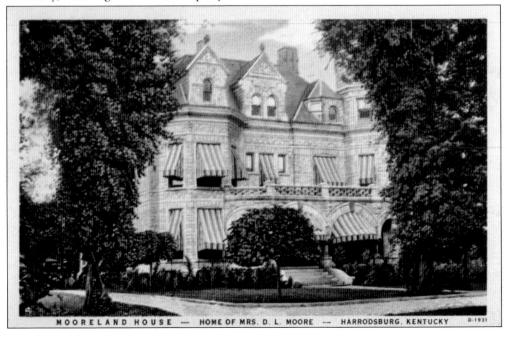

MOORELAND HOUSE — HOME OF MRS. D. L. MOORE — HARRODSBURG, KENTUCKY D-1931

Courtview was built around 1823 in the Federal style by Col. Richard Sutfield, a prominent local citizen and builder of several fine houses in town. The clear view from the front porch to the courthouse less than a mile away provided the house with its name and its unusual orientation facing away from the street. The interior has examples of woodwork attributed to Matthew Lowery.

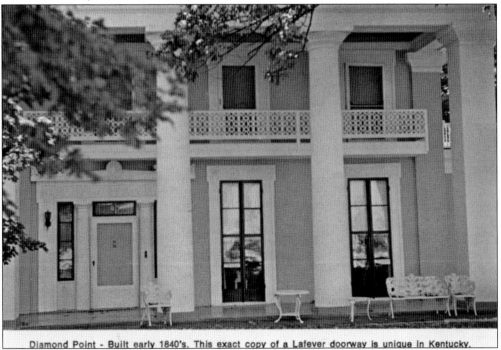

Diamond Point - Built early 1840's. This exact copy of a Lafever doorway is unique in Kentucky.

Diamond Point was built sometime between 1840 and 1848. It is one of Kentucky's finest examples of Greek Revival architecture and sits on a diamond-shaped lot, which may have inspired its name. Originally it might have faced College Street, but, when it underwent its Greek Revival renovation, its orientation was changed to face northward. The ornate balcony is not iron but carved wood and shows a New Orleans influence.

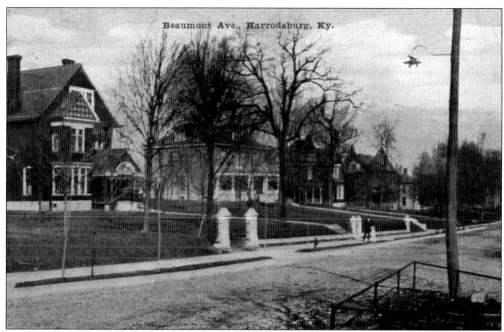

These cards feature views from the early 1900s of two of Harrodsburg's most impressive residential streets. Beaumont Avenue, above, and College Street, below, are lined with many historic and architecturally significant houses. Shown in the card above, from left to right, are the Dedman House, the VanArsdall-Sale House, and the Poteet House. The College Street card, from left to right, shows Rykon, Forest Pillars, and the Coleman House. A variety of architectural styles can be seen on both streets: Federal, Greek Revival, Queen Anne, Victorian, Bungalow, Shingle Style, and regular frame and brick houses mixed in with their more elaborate neighbors. Beaumont Avenue was named for nearby Beaumont College, later Beaumont Inn. College Street received its name because of the location of old Bacon College at its north end. There are more mansion-style homes lining College Street than any other street in town.

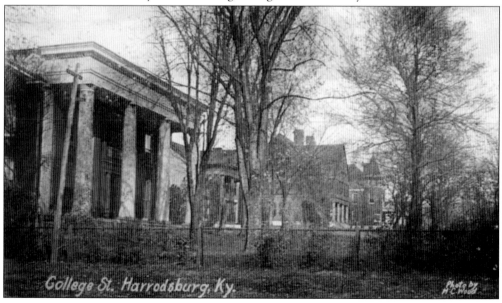

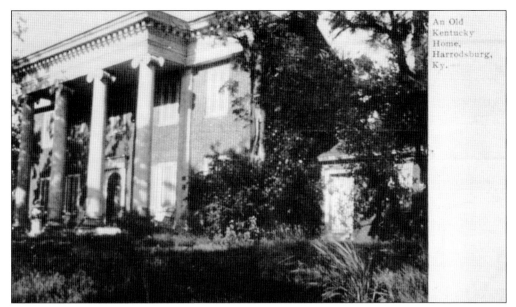

Clay Hill, around 1814, was built by Beriah Magoffin Sr. and is one of Harrodsburg's most imposing colonial homes, sitting on a hill with a large expanse of front lawn. Magoffin remarked, "I bought an old clay hill," thus unintentionally naming the house he was to build. There is handsome woodwork attributed to Matthew Lowery throughout the house. Kentucky's Civil War governor Beriah Magoffin Jr. was born there.

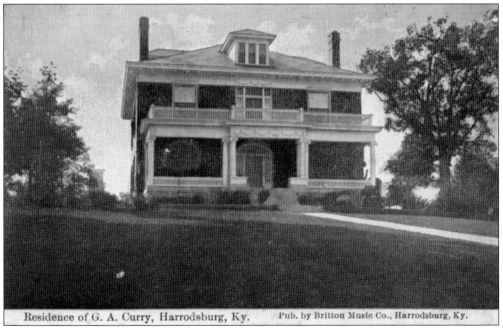

Residence of G. A. Curry, Harrodsburg, Ky. Pub. by Britton Music Co., Harrodsburg, Ky.

Built in 1905, the VanArsdall-Sale House is an example of the American Foursquare style, inspired by Prairie architecture characterized by box-shaped buildings. Creative builders often dressed up basic foursquares with ornamentation, such as the use of garlands on the porch frieze of this house. It was bought by Dr. Condit VanArsdall in 1919 and continues ownership in the same family.

The Dedman House on Beaumont Avenue was built in 1883 by the Charles Dedmans in the Queen Anne style. This architectural style was specifically made for upscale houses and produced a new building school that helped set the stage for 20th-century homes. Some prominent details of this home are tall brick chimneys, multiple high-pitched roofs, a wraparound porch, and a colorful decoration of colored glass in the stucco on the front facade gable end.

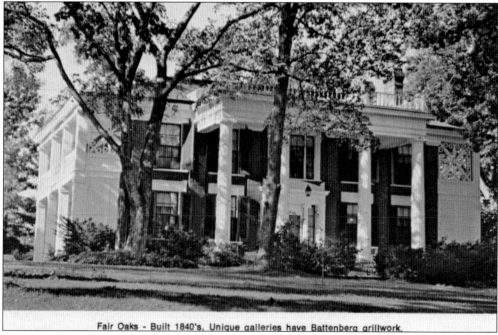

Fair Oaks - Built 1840's. Unique galleries have Battenberg grillwork.

In the early 1840s, Dr. Guilford Runyon built Fair Oaks, originally called Honeysuckle Hill, as a home for his bride-to-be. But she died of cholera in New Orleans without ever seeing the house. The house is built in the Greek Revival style, and in 1905, the large portico and columns were added. The open-air galleries on each side are reminiscent of New Orleans homes.

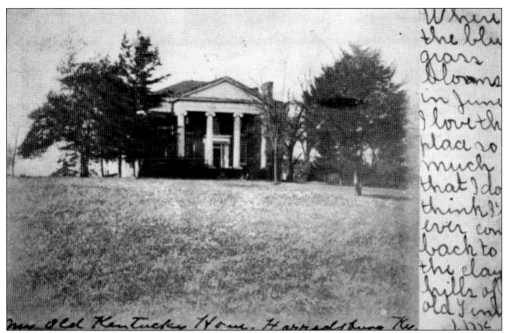

Where the blue grass blooms in June. I love this place so much that I do think I'll ever com back to the clay hills of old Tenn.

My Old Kentucky Home. Harrodsburg, Ky.

Aspen Hall, located off Beaumont Avenue on property that once belonged to nearby Greenville Springs, was built in 1840. It has been home to two college presidents. The first was its builder Dr. James Shannon, president of Harrodsburg's Bacon College, and the other was John Bowman, who helped found the University of Kentucky and later served as its president. Aspen Hall is one of the grandest of Harrodsburg's Greek Revival homes. The message on the card above reads, "Where the bluegrass blooms in June. I love this place so much that I don't think I'll ever come back to the clay hills of Tenn." The card below reads, "Dear Uncle John, Am living the simple life at Aspen Hall. Do wish you could be here at home with us. All nature is waking up and you would enjoy it. Will be to see you soon. F.R.W."

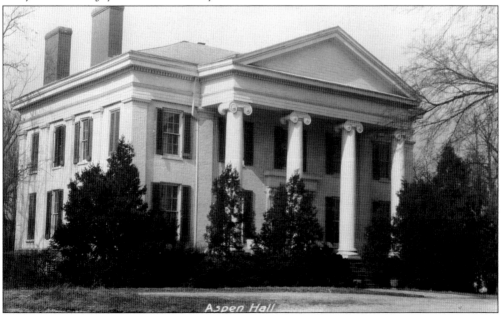

Aspen Hall

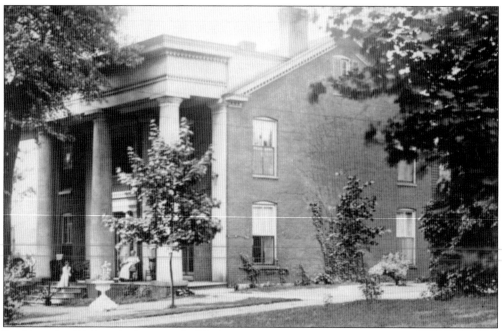

In this early-1900s real-photo card of Rykon, one can see two women sitting on the porch in long dresses, visiting on a summer afternoon. Business partners Daniel Stagg and James Curry built the Greek Revival house in 1843. In 1861, the house was sold to the Riker family, who named it Rykon and whose heirs kept the title for almost a century.

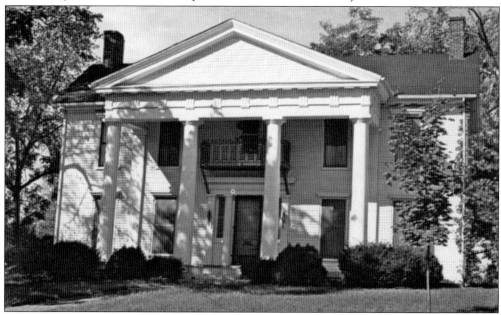

In 1823, Mary May had a log structure built on this property, but she only kept it for two years before selling it. Forest Pillars seems to have grown sporadically over the years, having elements of differing periods and a different kind of wood used in every room. The home's name is derived from the solid poplar tree trunks forming the columns. It was used as a hospital during the Battle of Perryville.

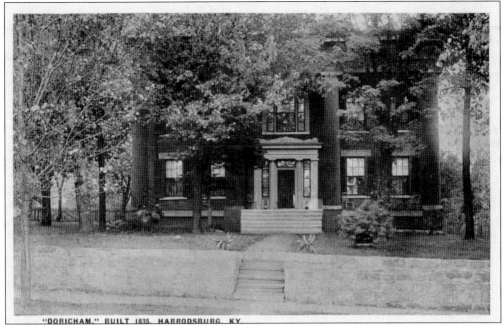

"DORICHAM," BUILT 1835, HARRODSBURG, KY.

Doricham was built by Daniel Stagg in 1835 and has Georgian proportions, a Greek portico, and detailed carvings around the windows and doors. This house has been owned by several families prominent in both Harrodsburg and Kentucky history: Terah Haggin, son of an early Harrodsburg settler and father of multimillionaire James Ben Ali Haggin, and the Stephenson family, who were historians of Harrodsburg.

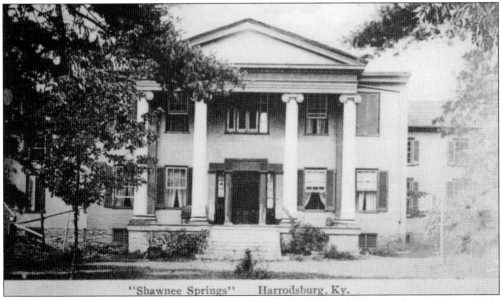

"Shawnee Springs" Harrodsburg, Ky.

The core of Shawnee Springs house was built by Col. George Thompson from 1788 to 1792. It was located on land several miles outside Harrodsburg, overlooking the Shawnee Springs named for the Shawnee Indians. This land had belonged to Hugh McGary, a member of James Harrod's party, which founded Harrodsburg in 1774. This Greek Revival mansion with so much history burned down in 1982.

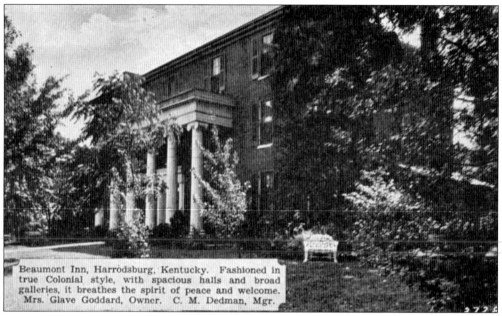

Beaumont Inn, Harrodsburg, Kentucky. Fashioned in true Colonial style, with spacious halls and broad galleries, it breathes the spirit of peace and welcome. Mrs. Glave Goddard, Owner. C. M. Dedman, Mgr.

This building, which is now Beaumont Inn, was constructed in 1845 and operated as Greenville Institute, a school for young ladies, until 1855. For the next 40 years, it was known as Daughters College, under the direction of noted educator John Augustus Williams. It changed hands again and, from 1894 until 1916, was Beaumont College. The school motto then was "Exalted character graced by elegant culture and refined manners." In 1917, Glave and Annie Bell Goddard purchased the property and converted it into Beaumont Inn. During its entire history, Beaumont Inn has been owned and operated by descendants of this family—into the fifth generation now. Beaumont Inn continues today as "Kentucky's oldest family-operated country inn," featuring antique-appointed guest rooms and traditional Kentucky cuisine.

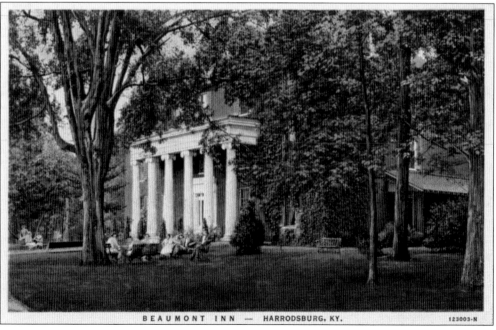

BEAUMONT INN — HARRODSBURG, KY.

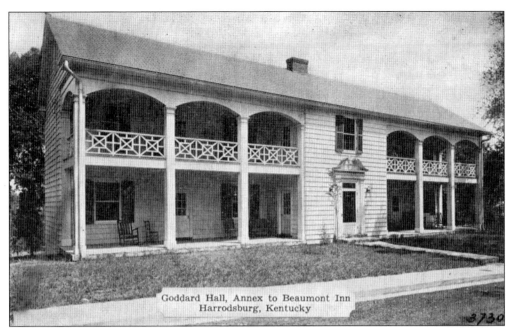

Goddard Hall, Annex to Beaumont Inn
Harrodsburg, Kentucky

Goddard Hall, designed and built by local contractor "Red" McClellan in 1935, is one of three buildings in the lodging complex known as Beaumont Inn. It has 10 units and is located across the street from "the Inn." The other building is Greystone, constructed in 1931 as a private residence just a short walk from the Inn, but later acquired for lodging.

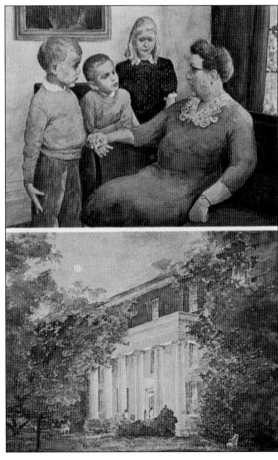

The painting shown at the top of this postcard is *The Story Teller*, which depicts the oldest and the youngest generations at Beaumont Inn—Mrs. T.C. Dedman Sr., known as "Miss Pauline"; her twin grandsons, Nick (left) and Chuck; and granddaughter Anne. At the bottom, *Night Light* depicts Beaumont Inn as it looks in the evening. Wooster Bard Field painted both watercolors in 1962.

73

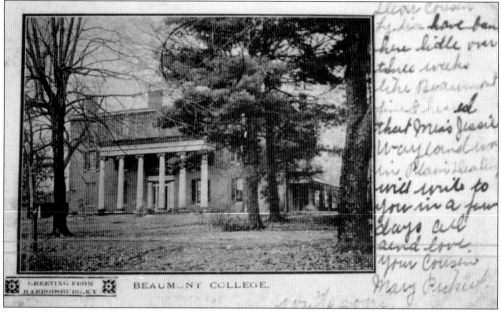

BEAUMONT COLLEGE.

Before it became an inn in 1919, this building housed Daughters College, a leading women's college in the South, from 1856 to 1891. The grounds had also been the site of the Greenville Institute from 1841 to 1856. Its modest frame building burned in 1841 and was replaced by the present brick building completed in 1845 at a cost of approximately $10,000. Daughters College offered women an academic curriculum comparable to the men's colleges of that era. Noted educator John Augustus Williams served as the president until his retirement in 1891, when it again changed hands and reopened in 1894 as Beaumont College. For 22 years, young ladies from around the country came to study such subjects as "Shakespearian writings, plane and spherical trigonometry, and evidences of Christianity," as well as the usual subjects. The college closed in 1916 and was converted into a lodging-and-dining establishment.

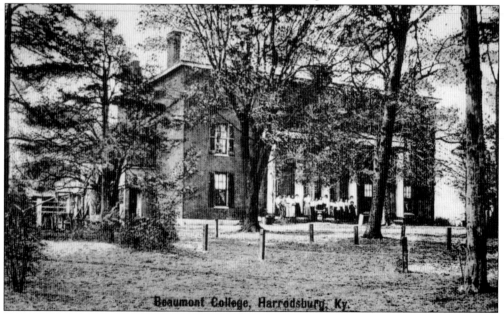

Beaumont College, Harrodsburg, Ky.

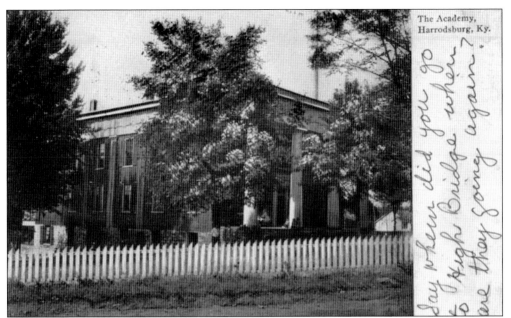

The Harrodsburg Presbyterian Church, located next door, had this Greek Revival mansion built in 1847 to establish the Harrodsburg Female Academy. In 1883, it was operating as a boys' school, the Hogsett's Academy. In 1895, it again was sold and became a coeducational high school, under the name Harrodsburg Academy. This school was recognized as one of the best high schools in the state. Its faculty was composed entirely of college graduates, and attendance was growing at such a rate that it was predicted to be one of the largest schools in Kentucky. Then in 1911, Harrodsburg established a public school system and, after 64 years of educating youth, this structure closed its doors as a school for the last time. Since then, it has been a residential-use building, often called Avalon Inn.

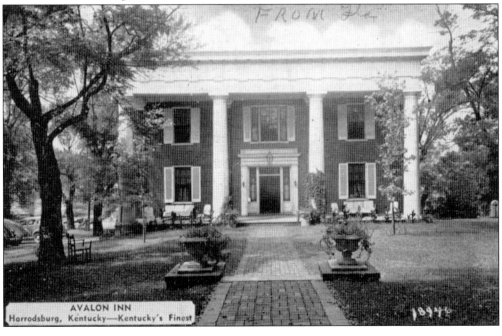

AVALON INN
Harrodsburg, Kentucky—Kentucky's Finest

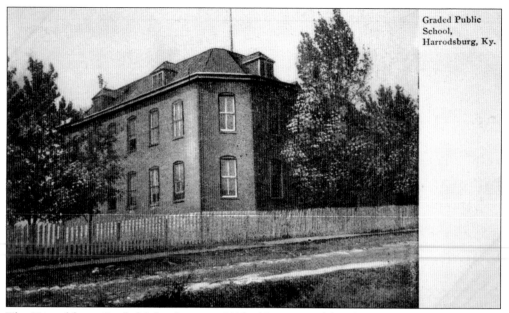

Graded Public School, Harrodsburg, Ky.

The Harrodsburg Graded School was established by a special legislative act in 1889; that same year, this impressive brick school was built at the top of the hill on North Main Street. There were 72 pupils enrolled for the first session. In 1893, an addition was built to provide space for increased attendance. Nearby Spilman's Addition provided homesites for families wanting to locate close to the new school.

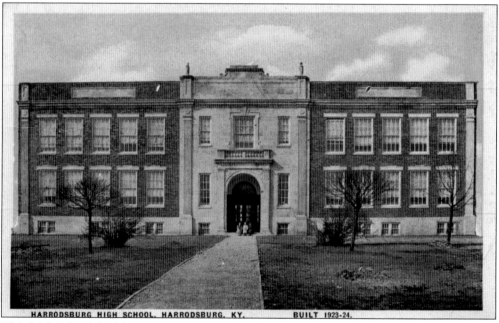

HARRODSBURG HIGH SCHOOL, HARRODSBURG, KY. BUILT 1923-24.

This high school building on East Lexington Street was completed in 1924. Prior to this, in 1911, a high school had been built directly south of the graded school on North Main Street. Within 13 years, it had been outgrown, and students moved across town to this new building. In the 1950s, a new elementary-and-junior-high complex was added, and the old school was closed.

76

EDUCATIONAL INSTITUTIONS.

Mercer County was a pioneer in education. Just as soon as the settlements were established, schools were begun. This can be attributed to the fact that the early settlers were from Virginia and the East, where the benefits of schools had been long established. In 1776, the first school was taught at Fort Harrod. Mercer Countians did not take much interest in public schools at first. The leading people were already educating their children in private schools. The following is a time line of Harrodsburg schools:

1839–1864	Bacon College (all-white, men)
1841–1856	Greenville Institute (all-white, women)
1847–1882	Harrodsburg Female Academy (all-white, women)
1856–1891	Daughters College (all-white, women)
Around 1874	start of educating black students
1883–1895	Hogsett's Academy (all-white, boys)
1889–1950s	Harrodsburg Public Grade School (all-white, coeducational)
1890–1919	Wayman Institute (all-black, coeducational)
1890	Harrodsburg Public School (all-black, coeducational)
1894–1916	Beaumont College (all-white, women)
1905–1911	Harrodsburg Academy (all-white, coeducational)
1905–1929	first West Side School (all-black, coeducational)
1911–1924	high school on North Main Street (all-white, coeducational)
1924–2006	Harrodsburg High School (all-white [until 1962], coeducational)
1930–1961	new West Side School (all-black, coeducational)
1962	Integration

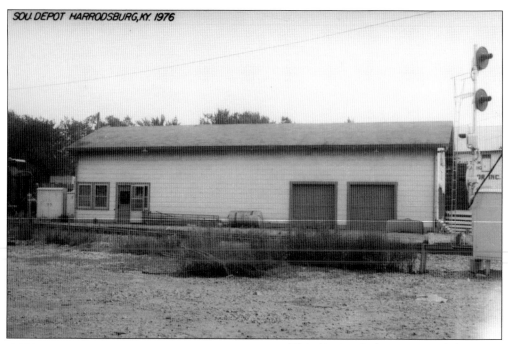

SOU. DEPOT HARRODSBURG, KY. 1976

This 1976 real-photo postcard shows Harrodsburg's last surviving railroad building, the Southern Railway freight depot, located on Marimon Avenue. It had been operating since 1951, but the changing nature of passenger and freight services had reduced it to a one-man operation for freight only. In 1973, the depot was closed, and the building used by a feed-and-grain business and later torn down.

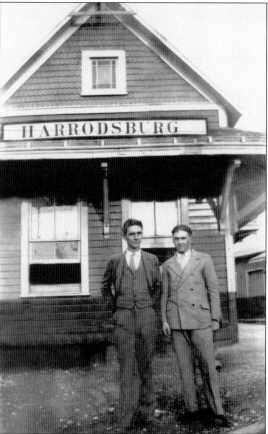

HARRODSBURG

In this real-photo card from the 1930s, two well-dressed young men take time to pose for a picture while waiting to either board the train or greet someone arriving. Sometime in the early 1900s, the old Southwestern depot on the corner of Office and Greenville Streets was closed, and this new one was built. By the 1970s, passenger service was no longer profitable, and the depot was closed and later demolished.

Three

GRAHAM SPRINGS

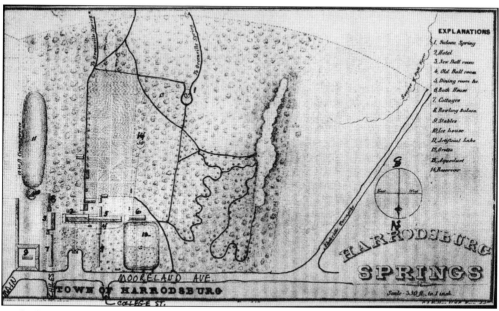

In the late 1820s, Dr. Christopher C. Graham bought the Greenville and Harrodsburg Springs properties and combined these two Mercer County watering places under the name of Graham Springs. The drawing lists the various buildings available for guest use. They are the hotel, old and new ballrooms, dining room, bathhouse, cottages, bowling saloon, and stables. There was also an artificial lake, the springs, a grotto, and a reservoir.

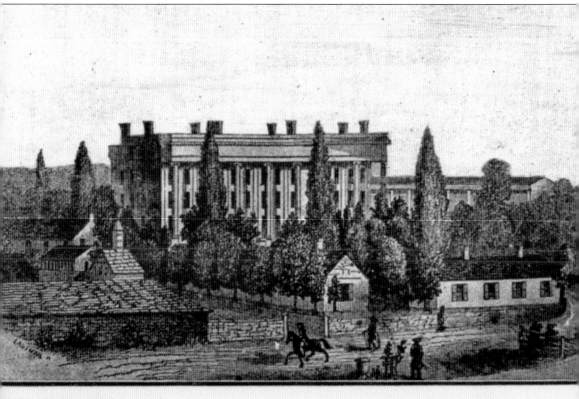

Graham Springs - Established 1820.

This early-1900s card was published by local photographer A.B. Rue. Dr. Christopher Graham, owner of Graham Springs, was one of Harrodsburg's most colorful characters. He successfully operated this "Saratoga of the West," whose heyday was in the late 1840s, as the most fashionable spa in Kentucky. The nearby mineral springs were thought to be beneficial for all types of aliments. During 1842–1843, he built an elegant brick four-story hotel, costing over $30,000. There was a 50-by-100-foot ballroom, cottages, a bowling alley, walking and riding paths, and a lake. The resort could now accommodate 1,000 guests at a rate of $20 per month. Wealthy families from the Deep South made the long trip by stage and steamboat to "take the waters" to ward off disease. Fancy dress and masquerade balls were popular during the social season, which lasted from June to early September. In 1853, Dr. Graham sold his resort to the United States government to be used as an asylum for aged and invalid soldiers, but this never worked out.

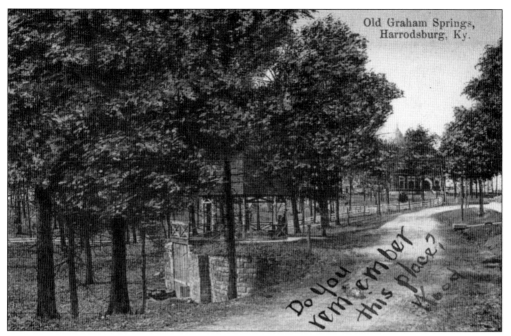

This 1908-postmarked card shows the springs on the far left in the trees and, in the distance, the New Graham Springs Hotel and winding walking path through the property. The guests could still, says the advertising brochure, "breath pure air in the shade with the forest drawing close about them that was planted by Dr. Graham so long ago."

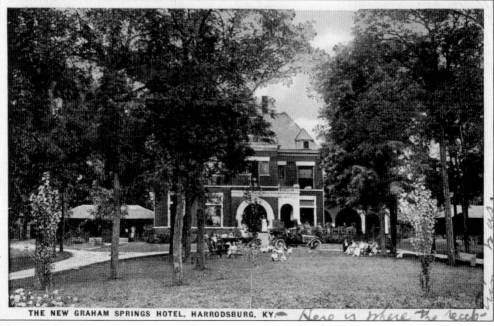

THE NEW GRAHAM SPRINGS HOTEL, HARRODSBURG, KY.

This card from 1917 shows a group of guests posing in front of the New Graham Springs Hotel, which was originally built as a private residence about 1888. When Ben Casey Allin bought it in the early 1890s, he opened the house as a hotel for summer boarders. It was located on 30 acres of the original Graham Springs property, now called the "Springs Addition."

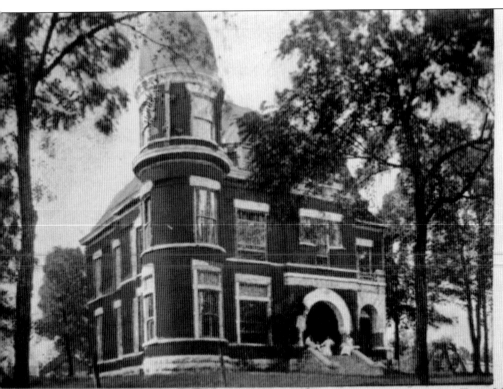

sidence of Ben Cassey Allen, Harrodsburg, Ky. Pub. by Britton Music Co., Harrodsburg, Ky.

This Romanesque-style house, with its stone arches and tower, was built around 1888 where Haggin Memorial Hospital is now located. Many postcards and photographs have been produced of this "New Graham Springs Hotel." It is interesting that the old Graham Springs Hotel, touted as the "Saratoga of the West," has only the drawing seen on page 80 as visible evidence of its existence. With the start of photography in the 1820s, it would seem like photographs would exist of such a unique resort before the main building burned in the 1850s. But the new hotel and grounds were well documented and much smaller and manageable, and the popularity of "taking the waters" was still fashionable and affordable, although times were rapidly changing. But at the turn of the century, more guests were coming than he could accommodate in the house, so he built cottages and a large combination dining and ballroom. But "a day that is dead will never come back" proved true, and with the war and Depression, the days of leisure and elegance were over, and the last Graham Springs Hotel closed in 1934.

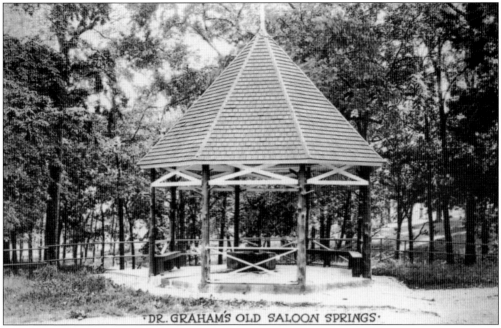

·DR. GRAHAM'S OLD SALOON SPRINGS·

The gazebo seen in turn-of-the-century photographs of Graham Springs looks just like the one that is there today, which is an eight-sided roof supported by cedar posts. The above early real-photo card shows this covering for the springhouse directly below. Surrounding the spring were trees and plants of many species planted there by Dr. Graham. Paths for walking and riding wound their way through the many acres of the Graham Springs property.

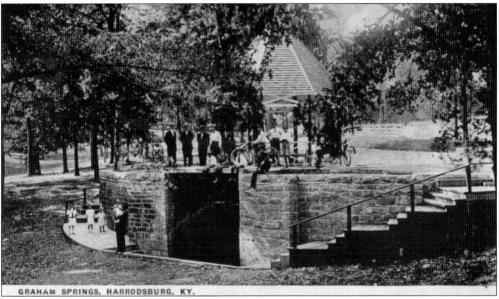

GRAHAM SPRINGS, HARRODSBURG, KY.

Here, one can see the springhouse where the curative epsom waters, thought to restore health and vigor when used both internally and externally, bubbled up from the ground. Graham Springs employees would carry large quantities of the water to cabins or treatment rooms with showers and tub baths, where the guests could be "steamed out." This was a popular site for guests and townspeople to meet and take photographs.

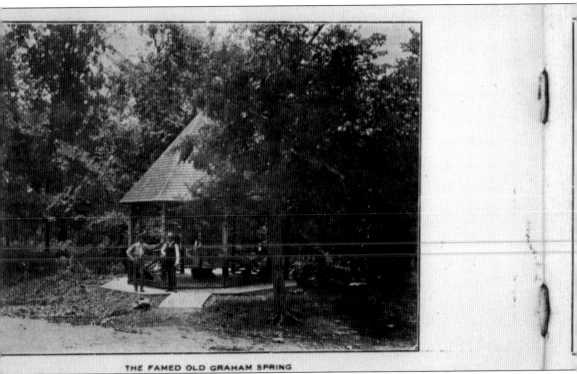

THE FAMED OLD GRAHAM SPRING

The text from a card folder advertising Graham Springs explains and praises the content of the mineral waters available for guests. Physicians strongly recommended both internal and external use for the best results. These waters were advertised as being especially beneficial for diseases of the "stomach, liver and kidneys, as well as for asthma, jaundice, skin diseases, consumption, brain fever, enlargement of the joints, chronic rheumatism, bronchitis, bilious

The celebrated Dr. John C. Gunn, in his treatise of the liver, dyspepsia, etc., says:

CAN NOT relinquish the subject of diseases of the liver without mentioning in terms of almost unqualified approbation my candid opinion of the waters of Harrodsburg (Graham) Springs, situated in the county of Mercer, State of Kentucky. These waters are known to act properly beneficially on the liver, nor do I believe there has been many instances, if an absolute consump- or induration of the liver had not taken place, in which these waters have not been efficient in oving diseases of the liver. Their almost certain efficacy is so well known that they are frequented housands of invalids during the summer months from every part of the United States. And I ld advise all persons laboring under complaints of the liver or dyspepsia or indigestion and who e become hopeless of the influence of medicinal prescriptions never to omit, if it be possible for n to travel to those springs, to give those waters a fair trial."

Dr. Gunn's analysis of the Waters of Graham Springs:

onate of Magnesia	0.26 grains		Chloride of Sodium	1.24 grains
onate of Iron	0.36 grains		Sulphate of Magnesia	27.90 grains
onate of Lime	2.99 grains		Sulphate of Lime	10.24 grains
	Total	42.99		

disorders, general debility, female weakness, ague, autumnal fevers, dropsy, gout, neuralgia, and dyspepsia." The geology of this area, which was rich in limestone, made it favorable for an inexhaustible number of medicinal springs. Dr. Graham advertised during the cholera epidemic of 1833 that "these springs are perfectly free from cholera."

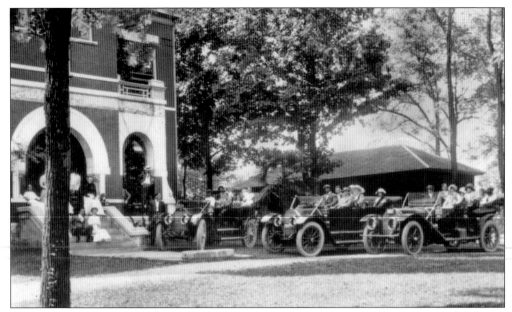

This real-photo card from the 1920s shows guests in their flivvers and on the steps of the New Graham Springs Hotel. On the back is a handwritten list of menu items: olives and pickles, spring chicken, old country ham, French peas, creamed potatoes, new corn, lettuce salad, beaten biscuit, salt rising bread, crème de menthe punch, ice cream, black cake, white cake, coffee, tea, buttermilk, cheese, bent crackers, and cigars.

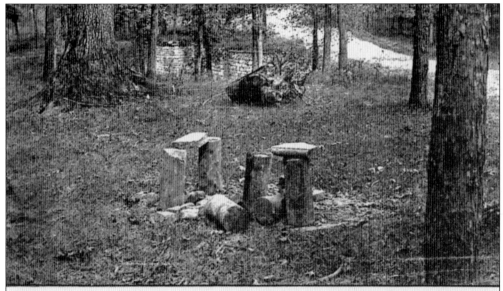

"The Lone Grove" by the Graham Springs. Its Occupant, a Beautiful Stranger, Dropped Dead in th Ball-room of the Springs Hotel, Back in the Forties. During the Excitement Her Handsome Partner, with Whom She Danced Each Set, Disappeared, Along with the Carriage in Which They Had Come.

These broken stones mark the site of the "Lone or Unknown Grave," located not far from the springs in the distance. All that is known is that the lady came to Graham Springs "gay and bewitching"; while she was dancing one night, death claimed her as mysteriously as she had come. Since her dance partner disappeared, the unidentified woman was buried under the trees.

Four

Chinn's Cave House
and Brooklyn Bridge

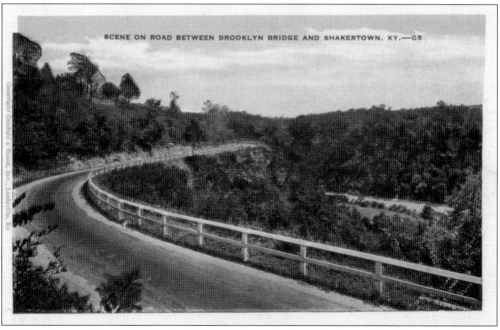

SCENE ON ROAD BETWEEN BROOKLYN BRIDGE AND SHAKERTOWN, KY.—G5

This scenic stretch of US 68 winds its way through the palisades of the Kentucky River in Mercer County to the Brooklyn Bridge and into Jessamine County. These towering limestone cliffs are located in the Bluegrass Region, where the Kentucky River cuts through the oldest rock formations in Kentucky, rising 400 feet above the river in some places. The area around Brooklyn Bridge is the site of the now vanished community of Brooklyn.

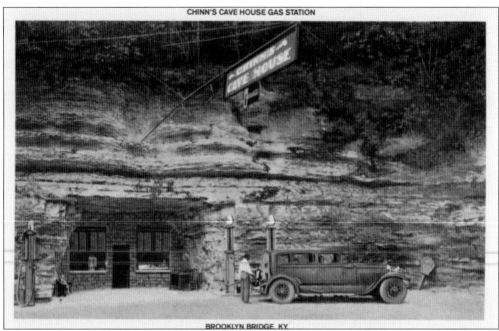

BROOKLYN BRIDGE, KY.

Chinn's Cave House, built in 1929, was located on the Mercer County side of the Kentucky River at Brooklyn Bridge on US 68. These postcards from the 1920s show that it was aptly named. One story about how the cave came to be was that in the 1920s Chinn, who had experience with blasting techniques at his grandfather's nearby fluorspar mines, blew out a tunnel several hundred feet into the cliff. Another story was that "Tunnel" Smith, who blasted out Boone's Tunnel just across the river, was hired to do the job. Regardless, it was a one-of-a-kind structure and had as colorful a history as its owner, Col. George Chinn, a Mercer County native. The Cave House is seen in the card above as it originally looked before the overhang was added. Restrooms located outside the cave are visible in the card below.

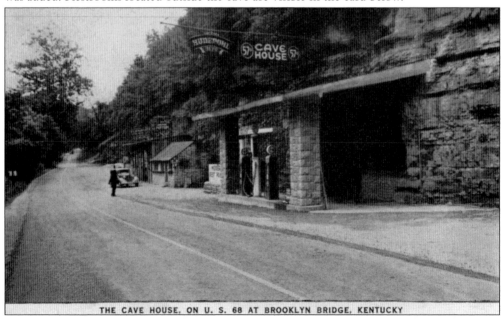

THE CAVE HOUSE, ON U. S. 68 AT BROOKLYN BRIDGE, KENTUCKY

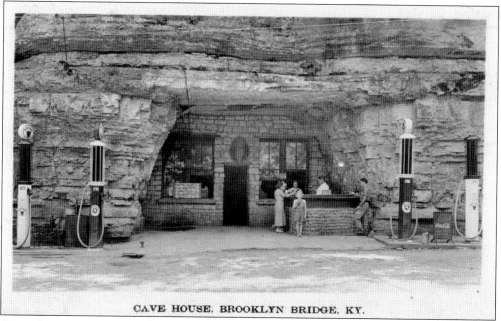

CAVE HOUSE, BROOKLYN BRIDGE, KY.

Gas and restrooms were available on the outside; food, drink, and novelties were found inside. This was possibly the only stop for gasoline available between Lexington and Harrodsburg at this time. Some travelers are using the outside counter to enjoy their food, and a Coca-Cola sign can be seen between the gas pumps. Chinn got the idea for this cave house business after visiting Bat Cave in North Carolina.

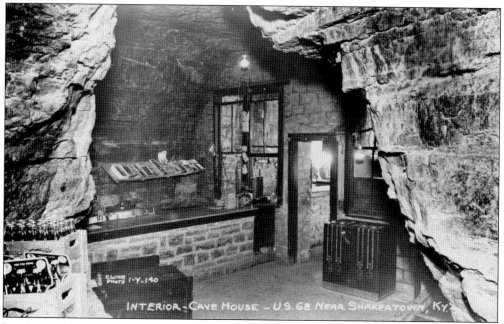

Just inside the door was a display counter for novelties, magazines, maps, postcards, and candy. A soft drink container can be seen on the right, and some cartons of drinks are sitting on a ledge of the cave wall on the left. The interior of the cave maintained a constant 57-degree temperature.

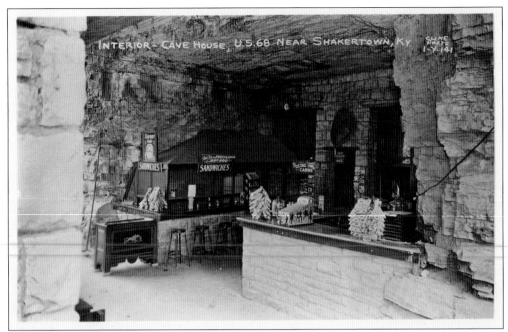

This is another view of the Cave House interior, featuring a sit-down counter where a patron could have a foot-long hot dog or a country-ham sandwich, often served by Chinn's wife, Cotton. The door in the center led farther into the cave tunnel, where it was rumored there was a bar and gaming machines. A hanging sign for Hudepohl beer was openly displayed at the entrance to the Cave House.

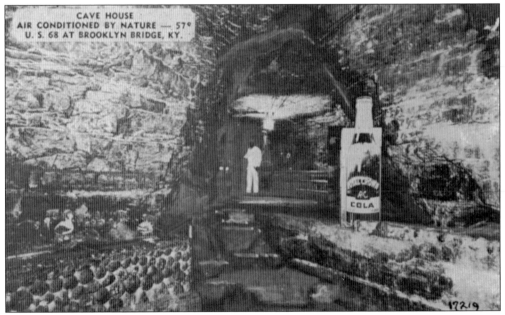

This is a view deeper into the cave showing the ledges that had been created after the initial blasting. They allowed space for displays, like this RC Cola sign, or storage for food and drink supplies. A gas station attendant can be seen in the background. A decorative display of geodes, a rock formation common to this area, can be seen in the lower left corner of this card.

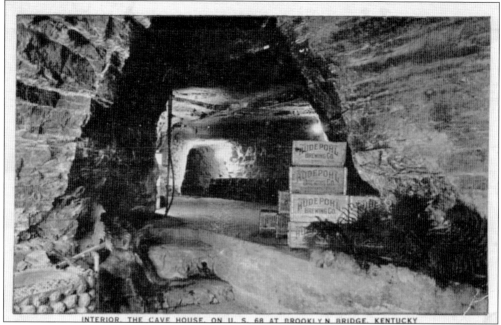

INTERIOR, THE CAVE HOUSE, ON U. S. 68 AT BROOKLYN BRIDGE, KENTUCKY

Sometime in the 1930s, this great roadside Americana attraction closed to the public. But years later, Chinn, who was a retired colonel in the Marine Corps and a weapons expert, was called back into service to develop a gun that could be used in Vietnam. The Cave House was the perfect place to test this new weapon. The result was the MK–19, a high–velocity grenade launcher.

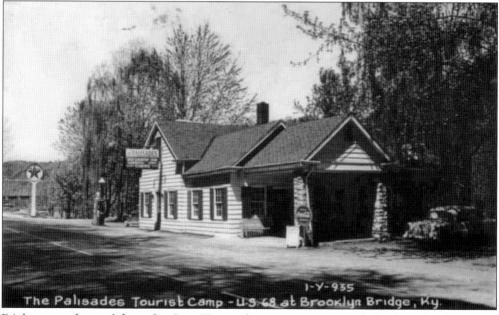

The Palisades Tourist Camp - U.S. 68 at Brooklyn Bridge, Ky.

Right across the road from the Cave House, there was a restaurant in business for close to 70 years. In this card from the 1950s, it is The Palisades, advertising country ham and tourist cabins. In a 1940s picture, it is Peniston's, again advertising country ham. There is parking for cars on both sides of the road at this popular stop for travelers in the "canyon of the Kentucky River."

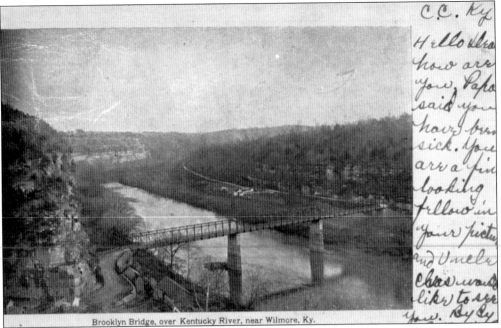

Brooklyn Bridge, over Kentucky River, near Wilmore, Ky.

The Kentucky River, towering limestone cliffs called palisades, forests of native trees and plants, and a 250-foot-long iron truss bridge, all located in the now vanished community of Brooklyn, made this area "one of the show places of the nation–a magnificent scenic and historic spot," according to a 1929 article. The bridge was completed in 1871 and operated as a toll bridge. In 1906, Mercer and Jessamine Counties jointly bought the bridge, ending the tollgate era. The last tollhouse in Mercer County was the one here regulating Brooklyn Bridge. Nearby Cogar's Ferry, which had been operating since 1845, lost most of its business to the bridge and soon shut down. Captain Cogar had the honor of being the first to cross the bridge by driving the local stagecoach across.

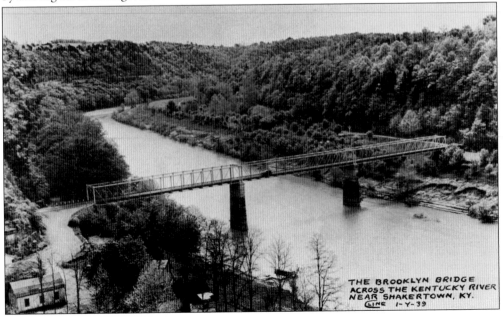

THE BROOKLYN BRIDGE ACROSS THE KENTUCKY RIVER NEAR SHAKERTOWN, KY.
CLINE 1-Y-39

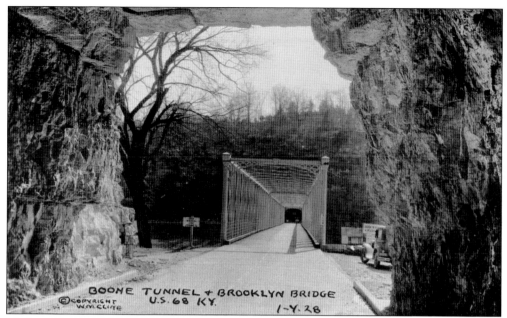

BOONE TUNNEL & BROOKLYN BRIDGE
U.S. 68 KY.
©COPYRIGHT
W.M.CLINE
1-Y.28

The old iron structure of Brooklyn Bridge was designed for the light loads and leisurely travel pace of the horse-and-buggy days. As more motor traffic and heavy trucks appeared on the roads, the problem of maintaining the bridge's structural safety became important. Another issue was a stretch of road on the Jessamine County side that was extremely dangerous. In 1927, the road was improved, and a tunnel was blasted through the cliff, allowing direct passage to the bridge. Boone Tunnel was the first highway tunnel in Kentucky and became quite a tourist attraction. In 1953, the bridge collapsed one morning as a delivery truck from Lexington crossed, seriously injuring the driver. A temporary Army-surplus Bailey bridge was put in place to carry traffic until a modern concrete bridge could be built. This marked the passing of an era for travel over this scenic road.

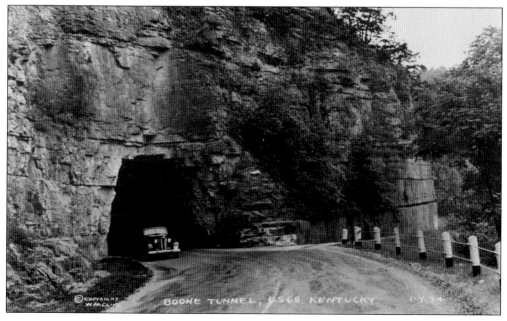

©COPYRIGHT
W.M.CLINE
BOONE TUNNEL, U.S.68, KENTUCKY
1-Y-34

93

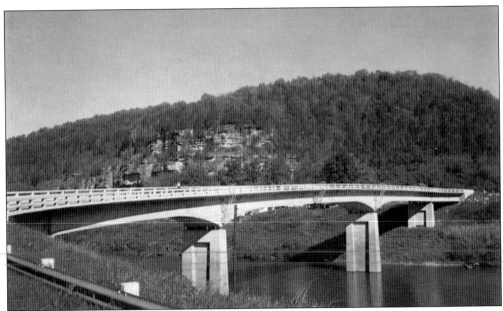

Immediately after the old bridge collapse, plans were started for a new bridge and approaches downstream from the Boone Tunnel crossing. The new location would bypass Boone Tunnel and close it to traffic. The new Brooklyn Bridge, completed in 1954, is of reinforced concrete resting on concrete piers, atop steel piles anchored in concrete bases below the water line. The new bridge was the first built in Kentucky to have a curve in it.

This is a view from Brooklyn Bridge of the Kentucky River facing upstream toward Lock No. 7 and High Bridge. This 22-mile stretch of river is known as Pool No. 6, between Locks Nos. 6 and 7. Locks Nos. 5 through 14 have been permanently sealed, with only the pools between locks being navigable. In days past, there was a dock, ramp, restaurant, and picnic tables here, and the river was alive with boaters and fishermen.

Five

HIGH BRIDGE

High Bridge spans the Kentucky River between Jessamine and Mercer Counties, and the community of High Bridge is in Jessamine County. But High Bridge, located just below the confluence of the Kentucky and Dix Rivers and across from Shaker Landing, has always been an area attraction for Mercer Countians. The bridge itself was an engineering marvel. Both rail and boat excursions to High Bridge Park were popular during its 1920s heyday.

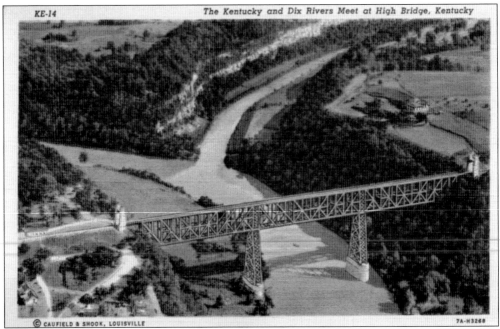

© CAUFIELD & SHOOK, LOUISVILLE 7A-H3268

This aerial view shows High Bridge in relation to its surroundings. Three counties can be seen, Mercer on the right, Jessamine on the left, and Garrard in the jut of land in the middle at the confluence of the Dix and Kentucky Rivers. The famous palisades can be seen along the Dix River and fertile bottomland underneath the bridge. Lock No. 7 and High Bridge quarry are located nearby.

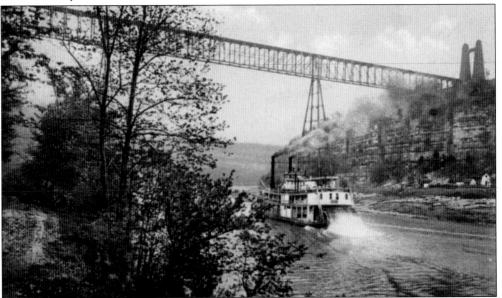

When High Bridge opened in 1877, it was the highest railroad bridge over a navigable stream in the United States, standing 275 feet above the low water mark. As word spread of the interesting and beautiful area, riverboat excursions became popular. Paddle wheelers would make weekly trips for passengers to either view the area from the boat or dock and let them climb the 271 steps of the wooden stairs up to the park.

This cliff's wooden stairway looks like it would have been an engineering feat in its own right. There were 271 steps in this stairway built in 1902 to allow boat passengers access to High Bridge Park at the top of this 300-foot cliff. It also provided access from the park down to the river, where one could get a close-up view of the understructure of the bridge. The steps weathered the 1937 flood but were accidentally set on fire and destroyed in 1948. In 1896–1897, the Army Corps of Engineers completed work on Lock and Dam No. 7 close to High Bridge and Shaker Landing. This was part of a project to make the Kentucky River navigable year-round along its entire length. In this card, the two buildings closest to the lock are houses for the lockmasters.

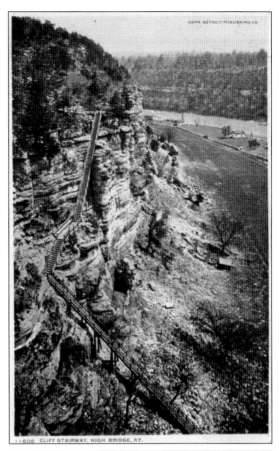

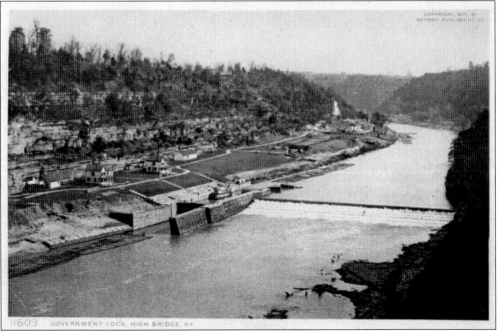

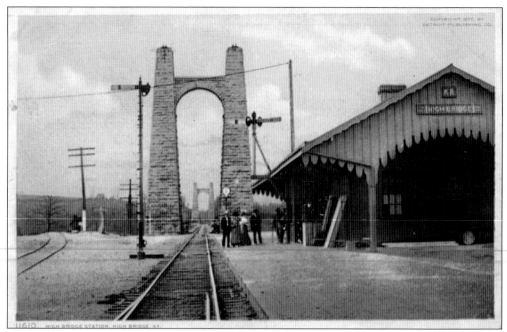

Located at the North Tower, seen in the background, is the first of three railroad stations at High Bridge. The station was built at the same time that the bridge was being completed in 1877. This wooden building was classic Victorian railway architecture and was the style used most often by the Queen & Crescent Railroad to accommodate its passengers. The Queen & Crescent was a system of railroads in the southeastern United States, connecting Cincinnati (the "Queen City") with New Orleans (the "Crescent City"), a distance of 827 miles. In the card below, one sees the original station that was moved to a spur track when the bridge was elevated 31 feet in 1910–1911. It was no longer a station but was used by the Southern Express Company for storage.

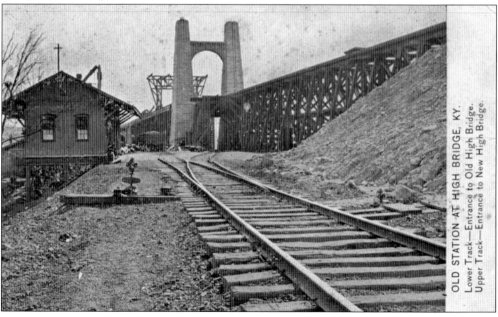

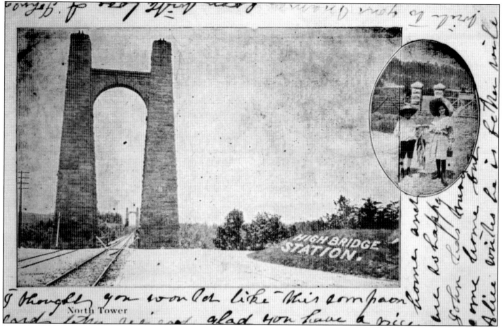

This 1906-postmarked card is a style popular in the early 1900s, which had a feature photograph and a small insert photograph, giving the card a little extra interest. Messages could only be written on the front at this time. This shows the road up to the rail station by the North Tower, which was nicely landscaped with "High Bridge Station" being spelled out in flowers.

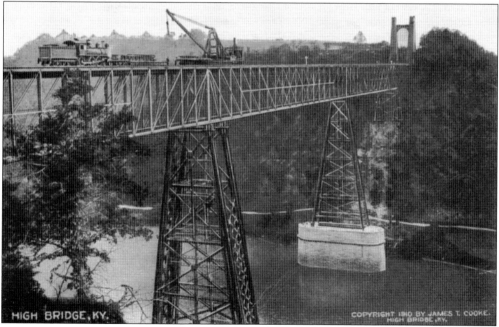

With increasing and heavier railroad traffic, it became evident that the bridge would need to be reinforced or rebuilt. In 1910–1911, the bridge was rebuilt around the original and used the same footings. By raising the track deck of the new bridge almost 30 feet above the existing deck, railroad traffic was able to continue uninterrupted during the rebuilding.

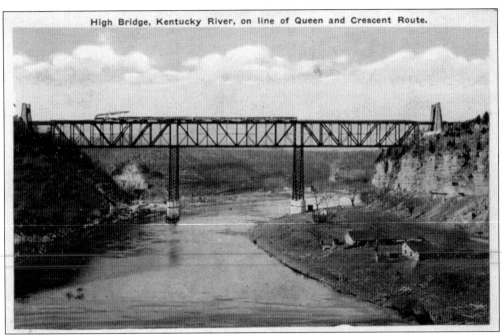

High Bridge, Kentucky River, on line of Queen and Crescent Route.

This awe-inspiring view was what attracted the excursion business. A 1912 advertisement in the *Harrodsburg Leader* reads, "Special Train Excursion High Bridge and Return. Sunday, August 18, 1912 via Queen & Crescent Route. 40c round trip. See the famous High Bridge – music – swings – picturesque scenery. Special train will leave Danville 9:25 a.m. Returning, will leave High Bridge 4:30 p.m." A 1913 painting by Ed Krakan, a Harrodsburg artist and jeweler, has been reproduced on the postcard below. Logging was a good business on the Kentucky River in the late 1800s. These logs were floated down the river and were destined for the High Bridge Lumber Company, the first sawmill loggers would come to. They were branded for identification before being sent downriver. A wooden tramway would take the logs from the river up to the sawmill at the top of the cliff.

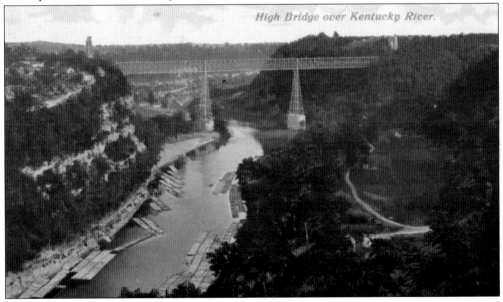

High Bridge over Kentucky River.

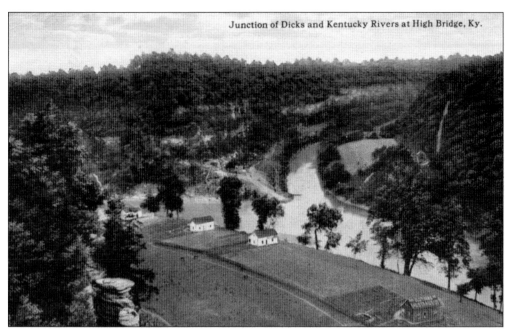

Junction of Dicks and Kentucky Rivers at High Bridge, Ky.

The confluence of the Kentucky and Dix Rivers is probably one of the most photographed scenes on the river. In this 1918 card, High Bridge would be just out of sight to the right, and some houses in the community of High Bridge seem to be dangerously close to the riverbank. On the house in the right corner, an enterprising homeowner has an advertisement on the roof, which could be seen by the passengers on the trains crossing the bridge. The jut of land in the center of the card is the location of what was Curd's Ferry. In this historic area, the Virginia legislature authorized a public ferry to operate as early as 1784 and approved the use of 20 acres of John Curd's land for a town and tobacco warehouse. High Bridge, as it looks today, is seen in the card below.

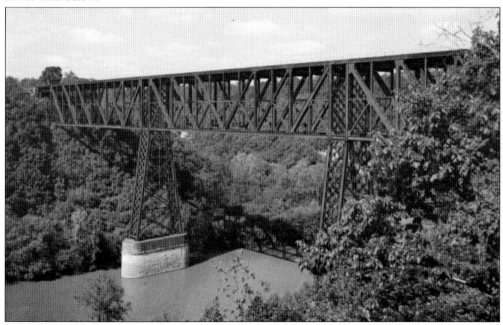

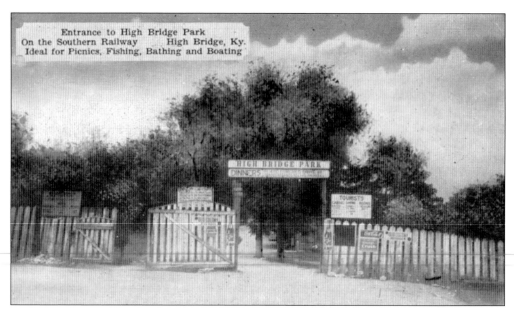

Entrance to High Bridge Park
On the Southern Railway High Bridge, Ky.
Ideal for Picnics, Fishing, Bathing and Boating

In 1879, the High Bridge Association was formed to establish a park adjacent to the North Tower. The park included picnic grounds, a restaurant, a dancing pavilion (seen below), riding stables, rustic shelter houses, and swings for children. In its early years, it was a popular assembly ground for cultural and religious meetings. Chautauquas and camp meetings were held, featuring such celebrities as William Jennings Bryan and evangelist Billy Sunday. As the passenger trains arriving at High Bridge declined and then disappeared, interest in the bridge waned. Only the occasional visitors found their way to the neglected park. Today, the park has had a rebirth. The Victorian-style pavilion is almost identical to the original one. Other improvements have been made, and the park is once again a destination for both locals and tourists.

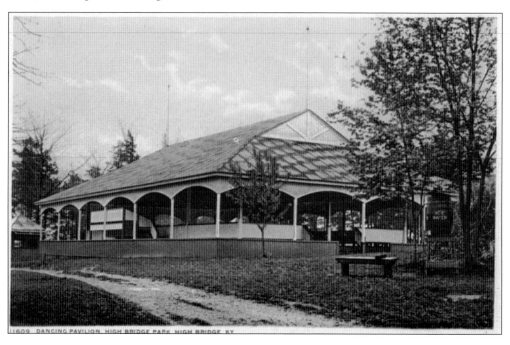

DANCING PAVILION, HIGH BRIDGE PARK, HIGH BRIDGE, KY.

Six

Dix Dam

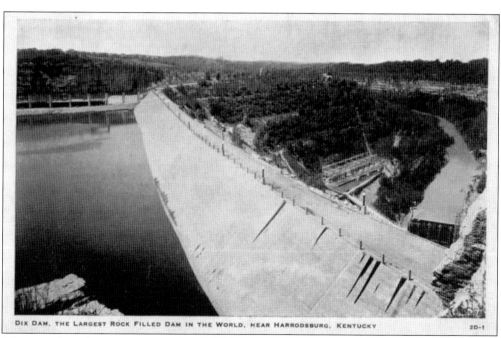

DIX DAM, THE LARGEST ROCK FILLED DAM IN THE WORLD, NEAR HARRODSBURG, KENTUCKY
2D-1

Dix Dam lies about 10 miles east of Harrodsburg. Construction was initiated in 1923 and completed in time to impound the spring rains of 1925. By the end of that year, Herrington Lake, created by the dam, had filled, and three hydroelectric generators were turning out the plant's maximum 30,000 kilowatts of power. Dix Dam was built by private enterprise and was heralded as one of the major engineering feats of its day.

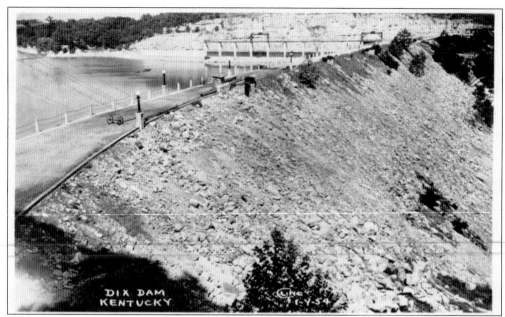

When Dix Dam was built, it was the largest rock-filled dam in the world. The Cline Photography real-photo postcard above shows the loose fill rock and Herrington Lake on the other side. The card below shows the entire expanse of the rock-fill and the powerhouse at the bottom. Rock blasted from the cliffs on the Garrard County side was used to fill the dam. The largest blasts involved the use of 80,000 pounds of dynamite and black powder. The loose rock was moved from the base of the cliffs to the dam by steam shovels, side-dump cars, and saddleback steam locomotives on a switchback system of railroad tracks from the riverbed to the top of the dam. This process was done until it reached a height of 287 feet, the height of the dam above the riverbed.

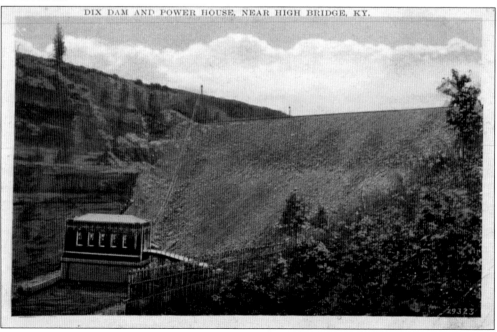

The powerhouse at the dam's base was a structure that would have little public visibility and could have been designed in a nondescript manner, but to the planners' credit, a handsome brick building to house the generators was erected. During the height of the construction, there were about 1,500 to 2,000 workers. A temporary town was built with bunkhouses, restaurants, offices, a movie theater, power plant, repair shop, waterworks, sewers, a fully staffed hospital, and police and fire protection. The completed dam was "287 feet above the riverbed, which was 150 feet higher than Niagara Falls." It stretches 1,087 feet across the Dix River Gorge between Mercer and Garrard Counties. The dam is 24 feet wide at its top and 750 feet wide at its base. J.W. McClellan, a Harrodsburg contractor, began his career working on Dix Dam for the Meyers Construction Company.

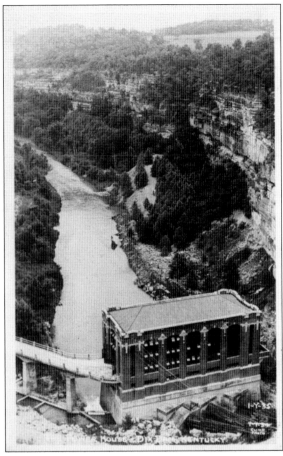

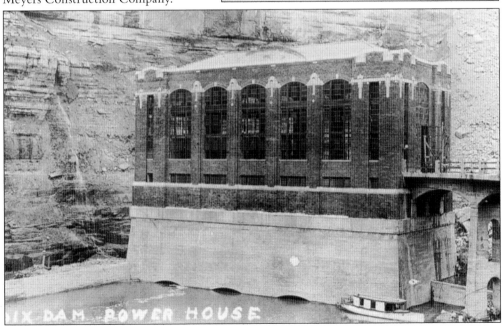

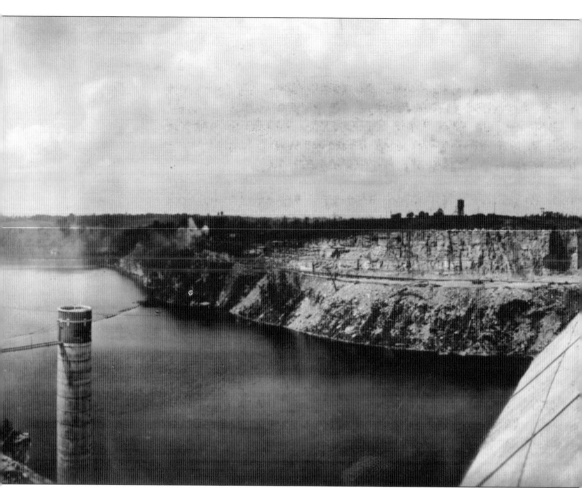

This wonderful 1925 real-photo card by Simmons Studio of Danville shows the sweeping panorama of Herrington Lake, Dix Dam, and the gorge with the Dix River flowing down to the Kentucky River. In 1909, L.B. Herrington, who owned a small power plant in Richmond, Kentucky, began gathering data that would lead to the construction of Dix Dam. The next 12 years were dedicated to gauging and recording the water flow at the present dam site. He

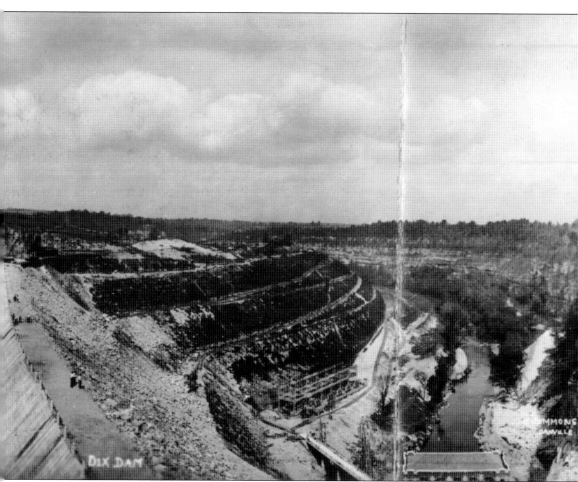

DIX DAM

noted there was a fall in elevation of 500 feet from the Dix River headwaters to where it emptied into the Kentucky River. (Niagara Falls only had a fall of 150 feet.) Herrington knew there was potential for tremendous power at that site. The Dix River Power Company was formed, which contracted with the Kentucky Hydroelectric Company, which later became Kentucky Utilities.

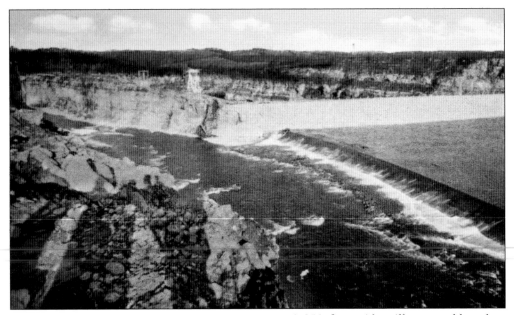

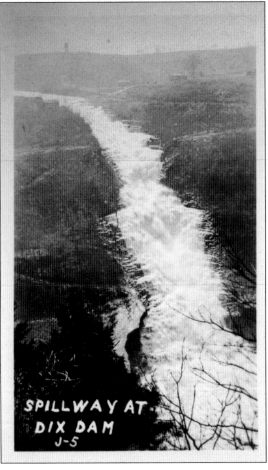

SPILLWAY AT DIX DAM J-5

A 250-foot-wide spillway was blasted from the cliffs on the Mercer County side to divert excess water from Herrington Lake during flooding. The water ran from the spillway, down a drop of several hundred feet to the Dix, and into the Kentucky River, about three miles. This Dix River gorge, with its towering palisades, was a popular place for hiking in the 1950s. When the spillway was opened, a crowd of locals would always visit to see the immense rush of water. A small island had been created close to the dam during construction, and the nearby E.W. Brown Steam Plant built a group of employee houses there, along with a pool, garden, and tennis court. This island was served by both a road and a swinging bridge, which was used when the spillway was opened.

Seven

HERRINGTON LAKE

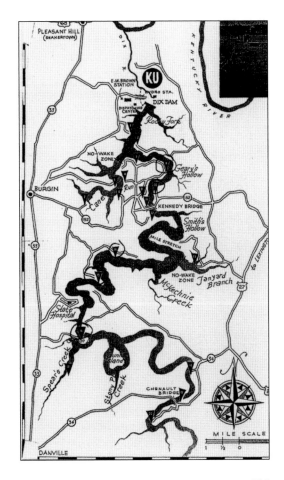

Herrington Lake was created by the completion of Dix Dam in 1925 to serve as a reservoir to provide water to operate a hydroelectric generating station. By the end of that year, the lake had filled. L.B. Herrington was its namesake and the man responsible for the creation of Dix Dam. This 1984 map shows a body of water snaking through the countryside for 35 miles up the Dix River valley.

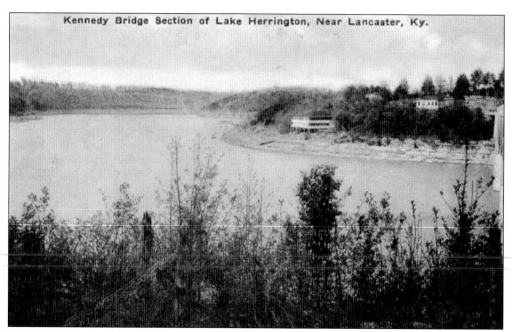

This 1940s view of Herrington Lake is from the Mercer County side at Kennedy's Bridge, looking toward the Garrard County side. Visible just across the lake is a large wooden structure, possibly a restaurant or some type of a tourist rental facility. Just beyond this building, the lake is wide and busy, with large marinas located opposite each other. This was one of the popular areas to cruise and be seen.

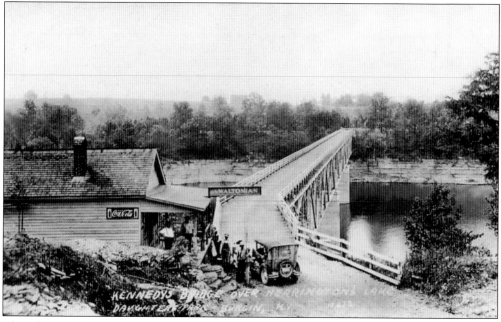

This old real-photo card from the 1930s shows the view from the Garrard County side, with Kennedy's Bridge connecting to Mercer County. A building has been at that location with a variety of businesses throughout the years. The sign reads, "The Waltonian," which sounds like it might be a place for entertainment. That area of the lake was known as Daughters Park.

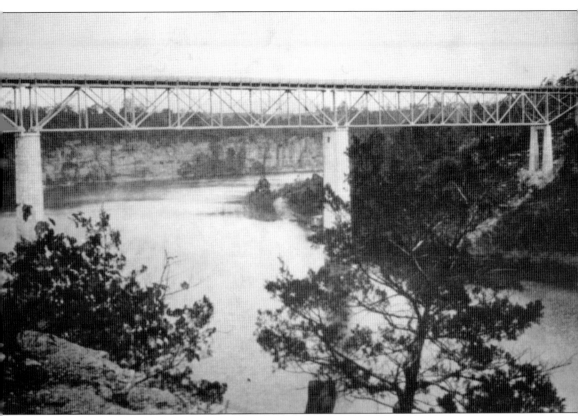

This real-photo card of Kennedy's Bridge appears to have been taken in the late 1920s, when the lake was still filling up. The formation of the lake left the Danville waterworks, a Kentucky highway garage, and two bridges underneath its waters. Normally, the water level would be close to the trees on the far cliff. This bridge was built in 1924, at the same time as the dam, to replace an existing wooden bridge over the Dix River at the bottom of a 250-to-300-foot-deep gorge. The new steel bridge spanned 800 feet across the lake and was only 20 feet wide, just enough for a single vehicle to cross at a time. The lake covers close to 3,600 acres and has over 300 miles of shoreline. The mean depth is 78 feet, but the depth near the dam is about 250 feet; it is Kentucky's deepest lake. Because the lake is so deep, it has only frozen from shore to shore twice, in 1936 and 1978. From the lake's earliest days, it has been a fisherman's and vacationers' paradise.

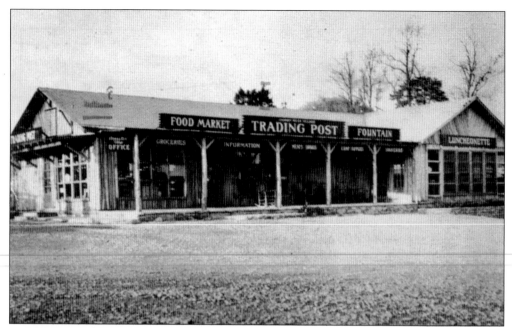

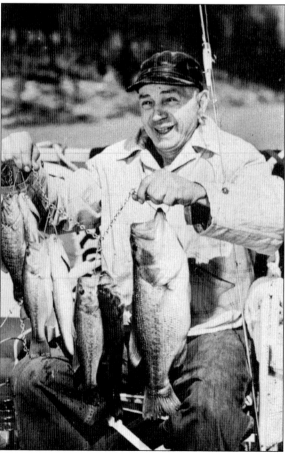

The Trading Post, at the intersection of Highway 152 and Ashley Camp Road, at Chimney Rock Village on Herrington Lake, was built in the rustic fashion of Chimney Rock buildings, using cedar logs. This 1955-dated card reads, "Colorful pioneer general store with large assortments of foods, drugs, meats, hardware, camping and fishing supplies, a gas station and exceptional luncheonette and soda bar. Souvenirs and gifts." Anna and Pierre's Restaurant relocated there in the 1970s. This Chimney Rock Resort card on the left should make any fisherman's mouth water. For decades, the black bass fishing lured anglers from all over the country. The lake was well stocked with crappie, bluegill, and catfish. Rainbow trout were also released into the Dix River below the dam for fly fishermen to try their luck at. Fishing camps were located from one end of the lake to the other.

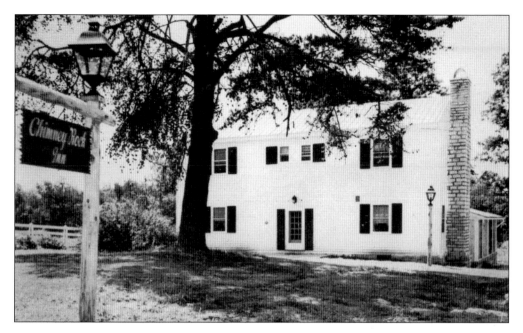

Chimney Rock Village was the brainchild of Arthur Ragona. A 1948 sales brochure for lots predicts that "the value of this property will, of necessity, increase with the years. A purchase of one of these choice sites now will be placing your funds in an investment of highly appreciating land." Those original lots sold for less than $1,000 each, and lots with small, one-bedroom cabins on them were priced at $10,000. Ragona would send a car to meet the prospective buyers at the Burgin train station. The original plans for Chimney Rock Village included cabins, a boat club, restaurants, a small hotel, and a general store to serve the community. Only the cabins and boat club became a reality. Today, only the cabins remain, and most of them have been modernized beyond recognition.

These real-photo cards from the 1950s were done for Arthur Ragona, owner of Chimney Rock Village. Ragona was one of the foremost boosters of Herrington Lake and was the president of the newly created Herrington Lake and Bluegrass Association, formed to promote the lake and surrounding tourist attractions. Local photographer and friend Andrew Armstrong did a series of these cards to provide material for future promotional pieces. Danville's Centre College owned a cabin for retreats and social functions, and Ragona often invited staff and cast members from nearby Pioneer Playhouse to spend a day on the lake. The young women unloading the woody are, from left to right, June Burns, Shirley Rice, Daisey Tewmey, and unidentified. The girls on the railing are, from left to right, June Burns, Mary Louise Patterson, Shirley Rice, unidentified, Jean Sanders, unidentified, unidentified, and Daisey Tewmey.

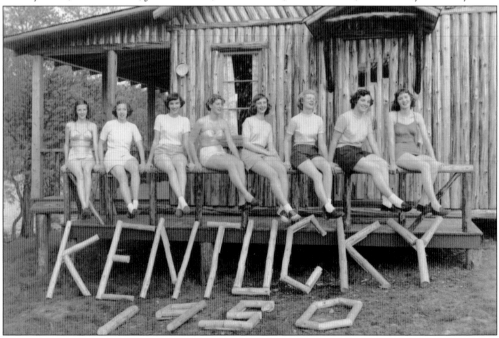

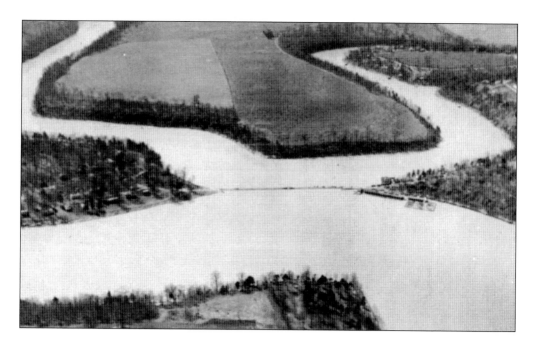

Gwinn Island was named for George Gwinn, who owned the nearby Gwinn Island Stock Farm. In this card, one can see the wooded island in the left center with the connection to the mainland. This connection was a hogback; when the lake was high, it was a true island, and when the lake was low, the hogback allowed one to walk across. Initially, a pontoon bridge for walking across was built, but then the hogback was improved into a one-lane road for vehicles. In the card below, the white frame building on the left is the lunchroom, and the docks and enclosed pools are on the right. The pontoon bridge is in the foreground. Public parking was at the top of the very steep road down, which was for private use only.

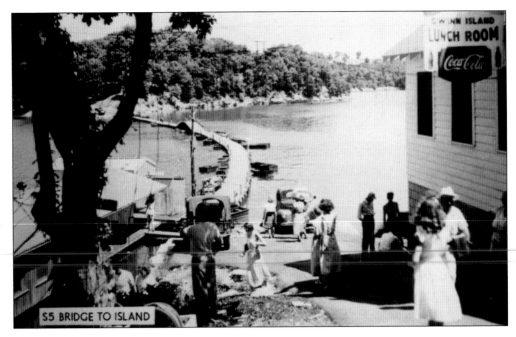

Gwinn Island was Herrington Lake's largest fishing camp and was owned by Dick Davis and his partner, Dave Biggerstaff, from 1938 until 1946. When they bought the property, the men "rehabilitated and revolutionized" the resort. They built a 600-foot-long pontoon footbridge to the island, several clubhouses, three large enclosed swimming pools in the lake, and a dining room. The 1940s was a boom time for them as fishermen, boaters, and swimmers flocked to the lake. They ran a full-service business by providing bait, lures, and other fishing supplies, as well as boat and motor rentals. And they catered to the many guests who stayed in the rustic cabins located on the island. The card above shows the completed pontoon bridge, which was raised in the middle so that small boats could pass through without having to go around the island.

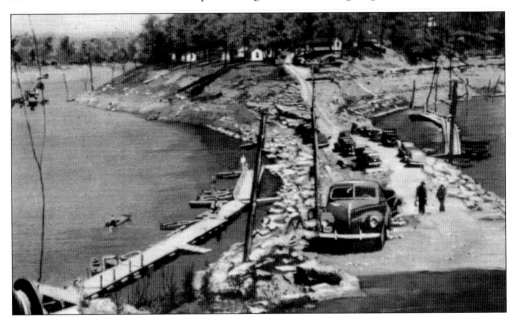

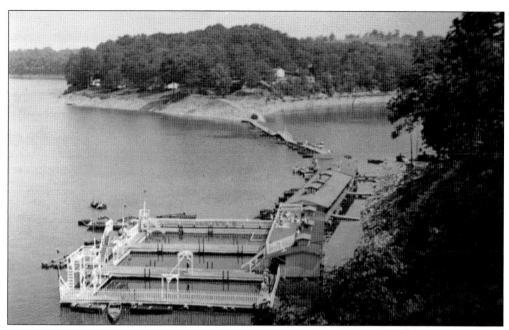

In these two cards, one can see two different sets of swimming pools at Gwinn Island. The card above is the older one, showing the pools built in 1938. The card at right could be from the 1960s, with the old wooden pools having been replaced with updated materials. In those hot, muggy Kentucky summers before air-conditioning, television, and a multitude of entertainment choices, Herrington Lake was everyone's favorite place to be, especially for young people. Teenagers swam, boated, and water-skied there. There was a ski ramp in the middle of the lake, and visitors could sit on the sun deck and watch all day. There was slimy moss covering the inside of the wooden slatted pools, and if a swimmer hung onto the side to rest while in the pool, soon the fish would be nibbling at his or her legs.

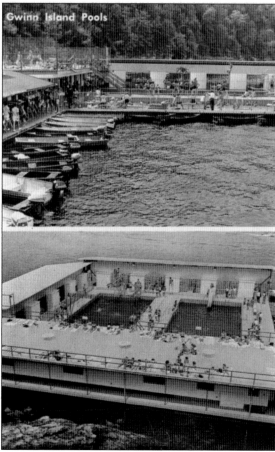

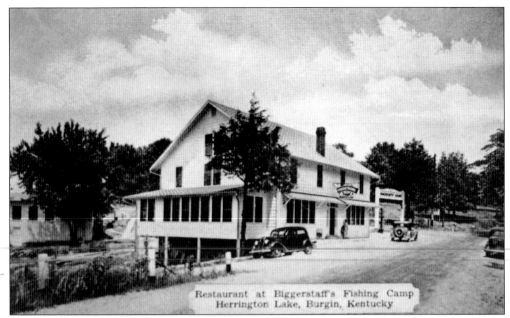

Restaurant at Biggerstaff's Fishing Camp
Herrington Lake, Burgin, Kentucky

Since the early days of Herrington Lake, there has been a marina on the Garrard County side of Kennedy's Bridge. The above card shows the restaurant at Biggerstaff's Fishing Camp in the late 1930s or early 1940s. An earlier building, possibly the first on that site, was torn down. The Hudepohl sign over the door invited guests in for a beer, and there were nickel, dime, and quarter slot machines for entertainment. Hard liquor was available from the bootlegger across the road. In the winter, men would gather there to play pool. The camp's advertisement reads as follows: "Johnson motor sales and service. 80 boats and motors. 17 cabins and 20 hotel rooms. Home cooking and pure drinking water in all cabins." The card below shows the same building, probably in the late 1940s, when it was the hotel and dining room at Gaskin's Fishing Camp.

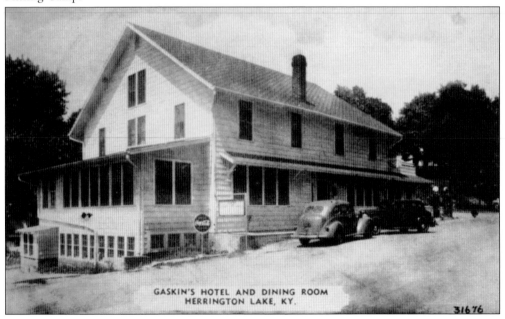

GASKIN'S HOTEL AND DINING ROOM
HERRINGTON LAKE, KY.

31676

118

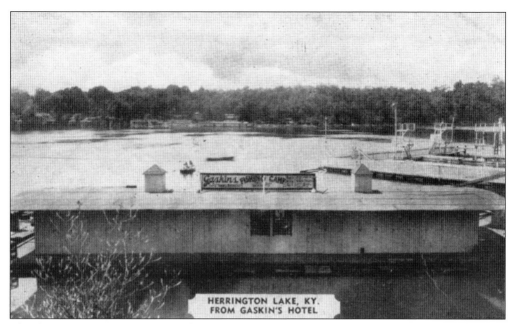

HERRINGTON LAKE, KY.
FROM GASKIN'S HOTEL

The docks and swimming pools of Gaskin's Fishing Camp, across Kennedy's Bridge in Garrard County, are seen in this early-1950s postcard. Herrington Lake had many small fishing camps located along its 300 miles of shoreline that were just a dock with boat rentals and bait. There were three big areas for docks and pools: Gwinn Island, this area in Garrard County, and the Chimney Rock area in Mercer County, just across from Gaskin's.

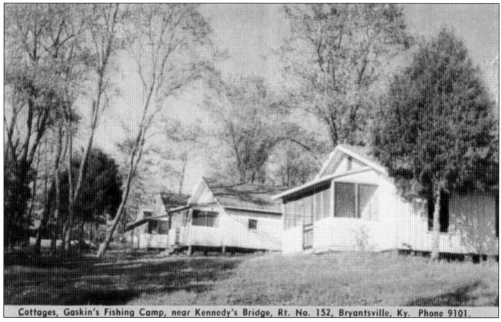

Cottages, Gaskin's Fishing Camp, near Kennedy's Bridge, Rt. No. 152, Bryantsville, Ky. Phone 9101.

This postcard advertises the following: "Formerly Biggerstaffs and Forbes – 3 hotels – 42 fully equipped cottages you can drive to – class A dining room & restaurant – boats & motors – modern floating swimming pools – horseback riding – fishing dock open 24 hours a day – purified water."

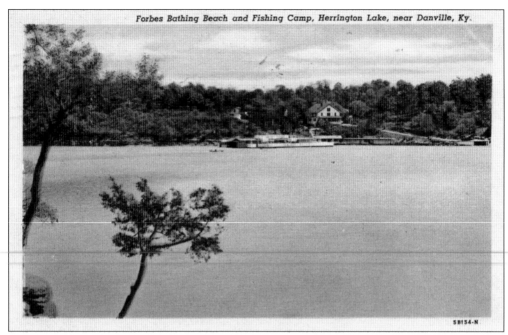

Forbes Bathing Beach and Fishing Camp, Herrington Lake, near Danville, Ky.

Sometime between when Biggerstaff and Gaskin owned this camp, Ralph Forbes had it for several years. This 1947-postmarked card reads, "Forbes Bathing Beach and Fishing Camp," but there was never a beach there, just the rocky bank down to the lake. An older man tells a story about a teenage summer of long ago, camping with friends outside under the trees or on the docks and working for no pay. In the 1940s, they hitchhiked from Lexington because nobody had a car or any money, and they worked around the dock and "fished, swam, and chased girls." In exchange for working at the dock, they had free use of a boat, bait, and supplies and "a Coke now and then." The card below shows the Kamp Kennedy Restaurant at the same location before it burned; it was not rebuilt.

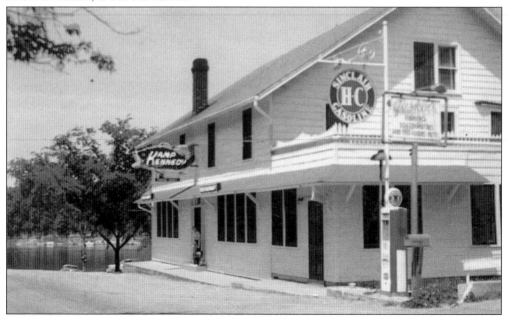

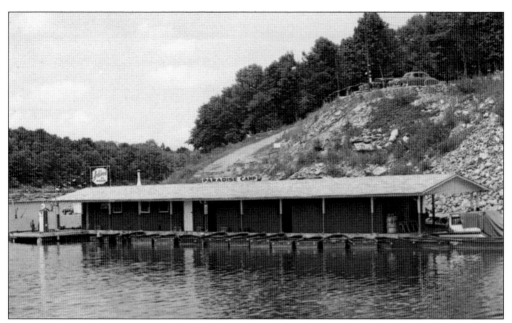

Paradise Fishing Camp is located on the Mercer County side of the lake and is about midway between the headwaters and Dix Dam. It is located on a stretch of the main lake across from Cow Pasture Point, where one can watch the cattle water at the lake's edge in the late afternoon. Paradise was just a small camp with a few cabins that has been on the lake since the 1950s.

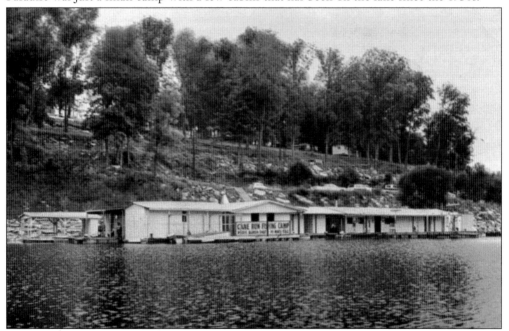

Cane Run Fishing Camp was located a short distance from Dix Dam in a cove off the main part of the lake. It has been there since the 1950s. Many of the smaller camps were located up these small, quiet coves. Cane Run had the usual dock and boats, but it also advertised a fishing parlor, which was like an enclosed wooden pool in the lake for fishing in any kind of weather or at night.

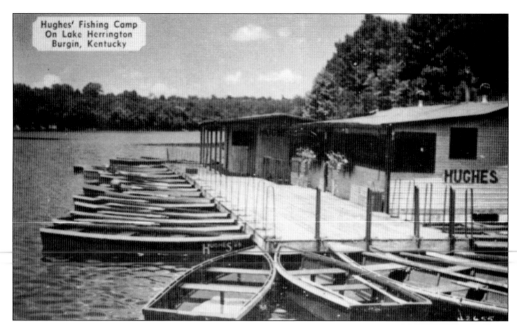

Hughes Fishing Camp was opened in the early 1950s and was located on the main lake channel, not far from Paradise Camp. It offered the usual dock, boats, bait, and cabins and, in 1966, advertised a new fishing parlor for night and all-weather fishing. Hughes and many other of the early marinas are just memories now. Bradshaw's Fishing Camp was located at the present site of Chimney Rock Marina. Ed Lane built the original camp in 1925, when the lake was formed. There were named cabins on the cliff above the dock: Big Cliff Cabin, Little Cliff Cabin, and Preacher's Cabin. There was also a hotel with a dining room, restaurant, and a residence. The Bradshaws bought this camp in 1946, and the enclosed pool in the lake was probably added then.

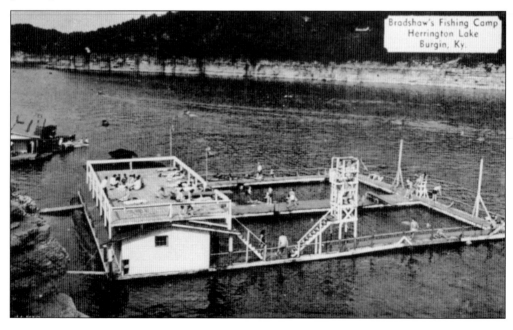

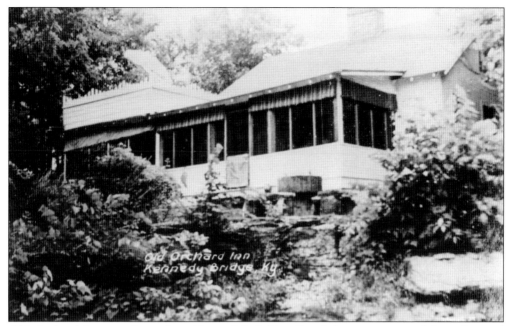

Old Orchard Inn was located on Kennedy's Bridge Road, between Kennedy's Bridge and the Trading Post, on the cliff's edge overlooking one of the busiest sections of Herrington Lake. It advertised "modern cottages with private bath and a modern restaurant specializing in steaks, chicken, seafood, country ham and hickory smoked pit-barbeque. We cater to clubs and large parties."

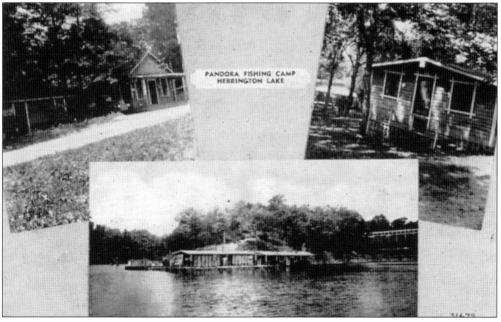

This marina located adjacent to Kennedy's Bridge has always been called Pandora, and there have always been several docks located in this area. The cove around from Pandora was the site of Old Foley Springs, where the Proctor family lived. When the lake filled, they ran Proctor's Grove Fishing Camp there. The multiview card is of Pandora's Fishing Camp in the 1940s.

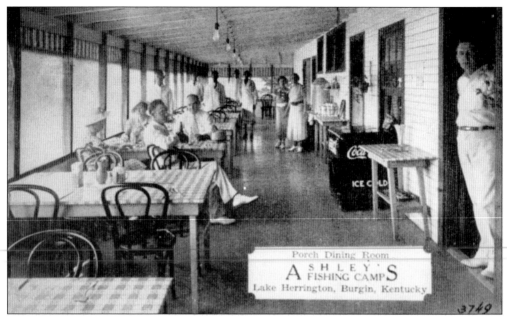

Porch Dining Room

ASHLEY'S
FISHING CAMP
Lake Herrington, Burgin, Kentucky

3749

Ashley's Fishing Camp, located near the mouth of Cane Run Creek, was built and owned by Carl Ashley in the 1930s and said to be the first camp built on Herrington Lake. The above card shows the dining room in what Carl Ashley called the "Dam View Inn." However, the only way to see Dix Dam was to lean far out the window at the end of the dining room. Some of the cottages at Ashley's Camp were named for the places vacationers came from. Although primitive by modern standards, these cabins were clean and had simple but comfortable furnishings. An advertisement from the 1940s reads, "30 completely furnished cottages, some with bath and electric range. Supplied with purified deep-well water. Accommodating from two to 16 persons. Dining room with seating capacity of 100. 60 first-class boats and motors."

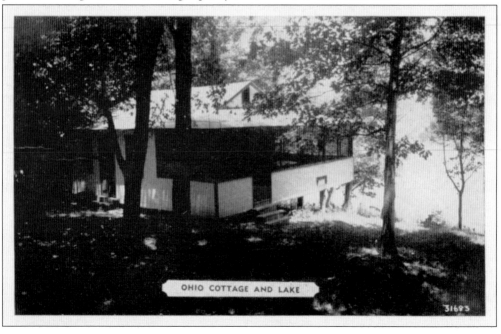

OHIO COTTAGE AND LAKE

31693

This is an unusual postcard from Ashley's Fishing Camp in the 1940s. Apparently a large fish was caught that had swallowed a smaller fish. The card is titled "Telescoped Fish Featured by Ripley." The weight of the big fish was 7 3/4 pounds, and the smaller one weighed 3 3/4 pounds. A view of the fish as it was caught is at the top of the card, and the view below that shows the two fish, after separation.

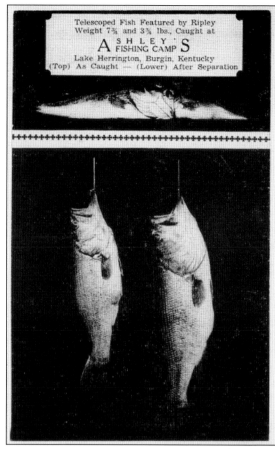

This card from the 1940s is of Kings Boat Landing at Chenault Bridge in Boyle County. This area is close to the southern end of the lake, near the headwaters where it is shallow. A 1940s brochure also lists Nave's Camp and Hick's Camp at Chenault Bridge. During a drought some years ago, the lake completely dried up in this area, and one could walk from one side to the other.

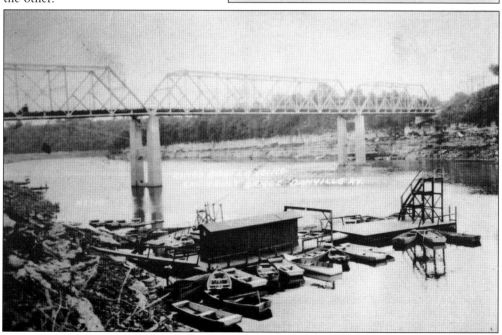

This real-photo card from the 1920s has "The Bathing Beauties" written on the back; the women are unidentified. It is hard to imagine why they did not sink to the bottom with so much clothing on. Whatever the time period, people have always been attracted to the water, whether to swim in it, sit by it, or boat on it. Some things never change.

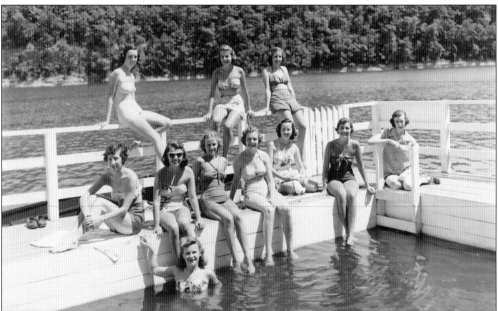

This real-photo card from the 1950s was taken at Chimney Rock on Herrington Lake at a bridal party given by Mary Mitchell Gravely for Elinor Patterson. Pictured are, from left to right, (on the railing) Barbara Jean Humber, Sitty Russell, and Mary Louise Patterson; (sitting) Elinor Patterson, Betty Ann Stole Haley, unidentified, Frances Barnett, Genie Carpenter Bissett, Ann Park, and Mary Mitchell Gravely. Mary Waters Chambliss is in the pool.

Index

DISCOVER THOUSANDS OF LOCAL HISTORY BOOKS
FEATURING MILLIONS OF VINTAGE IMAGES

Arcadia Publishing, the leading local history publisher in the United States, is committed to making history accessible and meaningful through publishing books that celebrate and preserve the heritage of America's people and places.

Find more books like this at
www.arcadiapublishing.com

Search for your hometown history, your old stomping grounds, and even your favorite sports team.